Typograp

VERY SHORT INTRODUCTIONS are for anyone wanting a stimulating and accessible way into a new subject. They are written by experts, and have been translated into more than 45 different languages.

The series began in 1995, and now covers a wide variety of topics in every discipline. The VSI library currently contains over 550 volumes—a *Very Short Introduction* to everything from Psychology and Philosophy of Science to American History and Relativity—and continues to grow in every subject area.

Very Short Introductions available now:

THE EUROPEAN UNION
Simon Usherwood and John Pinder
EUROPEAN UNION LAW
Anthony Arnull
EVOLUTION Brian and
Deborah Charlesworth
EXISTENTIALISM Thomas Flynn
EXPLORATION Stewart A. Weaver
THE EYE Michael Land
FAIRY TALE Marina Warner
FAMILY LAW Jonathan Herring
FASCISM Kevin Passmore
FASHION Rebecca Arnold
FEMINISM Margaret Walters
FILM Michael Wood
FILM MUSIC Kathryn Kalinak
THE FIRST WORLD WAR
Michael Howard
FOLK MUSIC Mark Slobin
FOOD John Krebs
FORENSIC PSYCHOLOGY David Canter
FORENSIC SCIENCE Jim Fraser
FORESTS Jaboury Ghazoul
FOSSILS Keith Thomson
FOUCAULT Gary Gutting
THE FOUNDING FATHERS
R. B. Bernstein
FRACTALS Kenneth Falconer
FREE SPEECH Nigel Warburton
FREE WILL Thomas Pink
FREEMASONRY Andreas Önnerfors
FRENCH LITERATURE John D. Lyons
THE FRENCH REVOLUTION
William Doyle
FREUD Anthony Storr
FUNDAMENTALISM Malise Ruthven
FUNGI Nicholas P. Money
THE FUTURE Jennifer M. Gidley
GALAXIES John Gribbin
GALILEO Stillman Drake
GAME THEORY Ken Binmore
GANDHI Bhikhu Parekh
GENES Jonathan Slack
GENIUS Andrew Robinson
GENOMICS John Archibald
GEOGRAPHY John Matthews and
David Herbert
GEOLOGY Jan Zalasiewicz
GEOPHYSICS William Lowrie
GEOPOLITICS Klaus Dodds

GERMAN LITERATURE Nicholas Boyle
GERMAN PHILOSOPHY
Andrew Bowie
GLACIATION David J. A. Evans
GLOBAL CATASTROPHES Bill McGuire
GLOBAL ECONOMIC HISTORY
Robert C. Allen
GLOBALIZATION Manfred Steger
GOD John Bowker
GOETHE Ritchie Robertson
THE GOTHIC Nick Groom
GOVERNANCE Mark Bevir
GRAVITY Timothy Clifton
THE GREAT DEPRESSION AND
THE NEW DEAL Eric Rauchway
HABERMAS James Gordon Finlayson
THE HABSBURG EMPIRE Martyn Rady
HAPPINESS Daniel M. Haybron
THE HARLEM RENAISSANCE
Cheryl A. Wall
THE HEBREW BIBLE AS LITERATURE
Tod Linafelt
HEGEL Peter Singer
HEIDEGGER Michael Inwood
THE HELLENISTIC AGE
Peter Thonemann
HEREDITY John Waller
HERMENEUTICS Jens Zimmermann
HERODOTUS Jennifer T. Roberts
HIEROGLYPHS Penelope Wilson
HINDUISM Kim Knott
HISTORY John H. Arnold
THE HISTORY OF ASTRONOMY
Michael Hoskin
THE HISTORY OF CHEMISTRY
William H. Brock
THE HISTORY OF CHILDHOOD
James Marten
THE HISTORY OF CINEMA
Geoffrey Nowell-Smith
THE HISTORY OF LIFE
Michael Benton
THE HISTORY OF MATHEMATICS
Jacqueline Stedall
THE HISTORY OF MEDICINE
William Bynum
THE HISTORY OF PHYSICS
J. L. Heilbron
THE HISTORY OF TIME
Leofranc Holford-Strevens

Available soon:

Paul Luna

TYPOGRAPHY

A Very Short Introduction

Great Clarendon Street, Oxford, OX2 6DP,
United Kingdom

Oxford University Press is a department of the University of Oxford.
It furthers the University's objective of excellence in research, scholarship,
and education by publishing worldwide. Oxford is a registered trade mark of
Oxford University Press in the UK and in certain other countries

First edition published in 2018

Impression: 1

Published in the United States of America by Oxford University Press
198 Madison Avenue, New York, NY 10016, United States of America

British Library Cataloguing in Publication Data
Data available

Library of Congress Control Number: 2018948468

ISBN 978-0-19-921129-6

Printed in Great Britain by
Ashford Colour Press Ltd, Gosport, Hampshire

Contents

Preface

Writing some thirty years ago, the self-confessed 'typomaniac' Erik Spiekermann could claim that it was 'difficult, if not impossible, to convince typographic innocents' about aspects of typography, and he could still refer (with almost a straight face) to 'initiates' who knew of 'typography's secret garden'. The proliferation and ubiquity of digital devices since then have changed things utterly, widening the circle of potential initiates to every user of a laptop, tablet, or smart phone. There is some irony to be found in the fact that it took the dematerialization of type, from metal to digital, to make it so widely present in so many minds. No longer innocents, we are now all asked to select fonts (that are fundamentally the same as those used by professionals) for our personal communications, however trivial. Discussions of users' favourite typefaces have moved from the annual conference of the Association Typographique Internationale to daytime television, with a consequent shift of focus from debates about legibility and technicalities to conversations about which fonts best reflect the user's personality or the style of their emails.

As a typographer, I find all this absolutely wonderful. The way we present language graphically has always been a subject for serious study, but often this work did not connect with or even reach the wider reading public. This book aims to move beyond considering the personality-value of typefaces to introduce some

recent ideas and research from leading writers on typography, and present them in a way that provokes thinking about the subject among a wide audience. It is not a how-to book, and it certainly does not claim to be a thoroughgoing history, either of printing or of graphic communication. Rather, it takes a broad definition of typography—as design for reading, whether in print, on screen, or in the environment—and draws out ideas about the development of letterforms, the organizational and perceptual issues behind key typographic decisions, and the differences between printed and on-screen typography. It will succeed if readers come away with a clearer understanding that typographic design is a series of rational choices, and they are inspired to learn more about (or even begin to practise!) the subject.

Acknowledgements

This book owes an enormous amount to colleagues in the Department of Typography & Graphic Communication, University of Reading, where, studying under Michael Twyman, I learnt to be a typographer and later returned to teach; at Oxford University Press (OUP), where I learnt how to put those ideas into practice; and at the Association Typographique Internationale. My thanks go to past and present staff and students at Reading with whom I've discussed these ideas, and who have read and commented on individual chapters (though any errors are of course my own). During my time at OUP, I was lucky enough to work with production staff and printers, as well as editors and lexicographers, who were committed to the highest standards (with none higher than those of my wife Judith, to whom this book is dedicated). I hope that some of the enthusiasm and knowledge that I gained from all these colleagues has rubbed off on this book.

The printed edition of this book is typeset in 8.5/12 pt Miller Text (designed by Matthew Carter), with headings in various weights and sizes of OUP Argo (designed by Gerard Unger).

List of illustrations

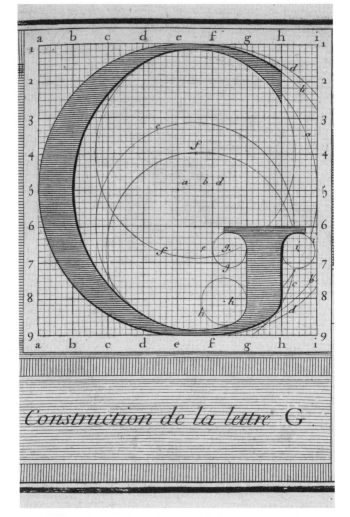

1. Engraving of a capital letter from an alphabet prepared by the French Royal Academy of Sciences in 1695. Engraved by Louis Simonneau, 1702.

Chapter 1
Perfect letters

Typography is design for reading. It is a set of visual choices designed to make a written message more accessible, more easily transmitted, more significant, or more attractive. Selecting the kinds of letters to use for any piece of typography is a fundamental design choice, because it can have an impact on all of these aims. Some are more legible, some are designed for particular technologies, and some strike us as having intrinsic emotional associations. What determines the shapes of the letters we use? Does it matter what kind of letters we use for a particular kind of communication? And why do the shapes of some letters have such extraordinary communicative power, capable of affecting the way we perceive the messages that are written with them?

We all know that printed documents look different from ones that we write by hand. The letters used in printing, or on a computer screen, are highly regular—perfect letters, you might say, that it would be difficult to imitate by hand. When we learn to write at school, we learn an alphabet of individual letters, drawn in a simple, basic, upright form—circles, parts of circles, and straight lines. Although the first books we read in school might have been printed in similar letters, almost none of the printed material that we subsequently encounter is presented in such basic letterforms. And as we grow more competent at writing, the basic letter shapes that we learnt are replaced by shapes that are more suitable for

rapid handwriting, with some letters joining others, and often with a forward slope to the right that follows the writing direction.

The letters in the books we later read, however, remain resolutely separate, and, for the most part, upright. They include shapes that are not taught as handwritten shapes, such as the a and the g. They often have little flourishes or terminals, and, unlike letters drawn with a ballpoint pen, have distinct thick and thin strokes. So it may come as a surprise to be told that all of these features, which seem to distinguish printed letterforms from handwritten ones, in fact originate in letters created by hand. The terms 'Latin alphabet' and 'Latin script' provide clues: our capital alphabet comes from the letters the Romans cut in stone; and our small letters come from the handwriting of Renaissance scribes.

What the Romans did for letters

The Romans used several letterforms simultaneously. For their grandest monuments, letters were carefully cut in stone. For commercial and political announcements, narrower letters were more rapidly painted on walls with a brush. And for personal writing on tablets and other materials, letters were adapted to be written in a flowing, continuous style, known as cursive, or 'running'. Roman inscriptions, public lettering cut by hand in stone, have held a fascination for anyone subsequently involved with letters because they represent part of a classical past that seems so assured and authoritative. The Romans, of course, used inscriptions in exactly the way any society uses written propaganda—for purposes of political and social power. The great triumphal arches in the Forum of Rome declare who held power— so much so that names were erased and replaced when regimes changed.

The letterforms and materials of Roman inscriptions suited their purpose exactly: the regular, careful capital letters were designed to be cut into stone outdoors, at massive scale, where they would

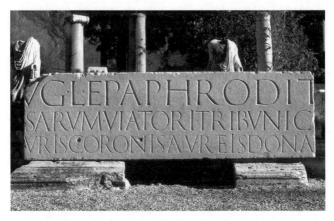

2. Roman inscription from the first century AD.

be seen in bright daylight (Figure 2). Accordingly, they were either deeply carved, so that the words were picked out by strong shadows, or originally filled with reflective metal. In all they were designed to impress. These letterforms combined legibility with fitness for the technology and they engendered an appropriate emotion. They were large enough and clear enough to be read from a distance, the shapes were made permanent by carving, and their regularity and refinement still speak of authority and purposefulness.

There seems to have been a division of labour in producing these inscriptions, with one craftsman laying out the inscription with a brush while another cut it. This prefigures the role of the designer in planning a piece of work, with the execution carried out by a craftsman or technician. These formal inscriptions used only what we call capital letters: evenly sized letters with relatively geometrical structures that are presented regularly and separately from each other. It is these Roman letters that are the basis of our capital ABC today. Indeed, as you wander around the Forum in Rome it is the familiarity of the shapes of inscriptional capital letters that is so striking. They may look formal and classical, but

unlike other ancient artefacts, they don't look out of date—because they look just like forms that we still use today.

Revival of the antique

Our small letters come to us through a less direct route: through the two great revivals of learning in western Europe, in the Carolingian period and in the Renaissance. Between the fourth and ninth centuries, letterforms based on the various cursive Roman hands had developed into a variety of competing styles in different parts of the continent. As part of the process of political centralization under Charlemagne (742–814), his scribes sought to impose control through the development of a single style with imperial authority. Their highly practical solution became known as the Carolingian minuscule (Figure 3), and centuries later it became an important inspiration for handwriting in the Renaissance.

In the intervening period new styles developed. The Romanesque period (the eleventh and twelfth centuries) was, according to the historian of lettering Nicolete Gray (1911–97), 'a time of experiment', and produced masterpieces such as the Winchester Bible (c.1150–75), with beautiful illuminated pages. From the end of the twelfth century letterforms became highly compressed, with considerable difference between thick vertical strokes and thin joining strokes—the style we recognize today as black letter, or Gothic. Pages written in this style became dominant all over western Europe but with local variations, such as the rounder rotunda style used in Italy. All variants share a close-knit texture, as if the object was to fill the space available as economically as possible. These letterforms achieve order and uniformity through relentless similarity—so much so that we now find it difficult to distinguish letters such as the m, n, and u in many instances. We cannot believe that scribes of the Middle Ages deliberately produced texts that were difficult to read, raising the question of whether the legibility of a text depends on intrinsic features of

its letterforms and layout, or whether familiarity determines our response to a document.

During the fourteenth and fifteenth centuries the revival of the Roman letter in Italy was a significant part of the humanist project that we now see as a driving force of the Renaissance. Humanist scholars sought to discover new classical texts, improve known ones, and disseminate their discoveries. They looked back to manuscripts that they thought were antique, but which in fact dated from the eleventh and twelfth centuries.

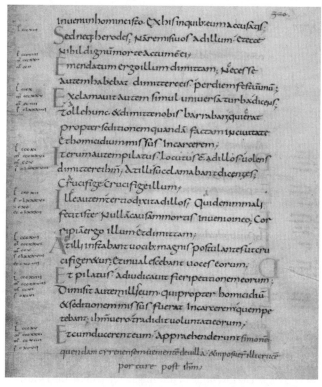

3. Carolingian minuscule in a manuscript Gospel Book, *c.*820–*c.*830.

From these late Carolingian models they developed two related scripts that were significantly different from the one that had been in recent use, and which had been used for official or professional purposes. The revived scripts, know as *litterae antiquae*—'antique letters'—were less looped, had fewer ligatures (joined letters), and were written either upright (the style of Poggio Bracciolini, 1380–1459), or with a slight slant (that of Niccolò de' Niccoli, 1364–1437).

Earlier forms of lettering were not immediately superseded. We can see how complex the process of the revival of the antique letter was in inscriptions on buildings in Florence, the most advanced and adventurous of Renaissance cities. The humanists, artists, and architects who wanted to revive classical lettering also took as their sources works that were actually made much later. Letterforms created in the Romanesque period, which were much more varied and fluid than their classical counterparts, were taken as models. For example, it was believed that the Florentine Baptistery (built between the fifth and eleventh centuries) and the church of San Miniato (its facade probably begun in 1090) were examples of genuine Roman architecture. This confusion led to hybrids of classical, Romanesque, and Gothic letters. Elsewhere in Florence, church facades by Leon Battista Alberti (1404–72) and the memorial in the Duomo to its architect Filippo Brunelleschi (1377–1446) use capital letters which combine forms that are genuinely classical with narrower, rounder letterforms that are typically Romanesque. Different shapes were often used for the same letter within one piece of work. This points to a period of experiment, when the newly revived Roman letter had not yet settled down into canonical forms.

The invention of printing

How did Roman letterforms become codified into the forms we know today? The invention of printing in the West in the 1440s, ascribed to Johannes Gutenberg (*c.*1400–68), was essentially

the invention of a way of making multiple copies of a text by creating separate reusable letters which could be combined in rows. A printed page could then be built up from these modular, reusable letter units. Block printing, that is printing pages from a single surface that included all the words and images of a text, had existed before Gutenberg, both in the East and in the West. But the blocks for one book were not reusable for any other. Gutenberg's invention provided the means to print any number of texts from a finite set of typographic resources, which could be reassembled and reused as necessary.

By mechanizing the production of letters, the invention of printing both fixed the Latin script and enabled systematic variation of it. In manuscript production, letters could be written more or less consistently, and adjusted where necessary, by a scribe; to be used in the production of multiple copies of a text, letters had to be manufactured for mass production. When multiple copies of an e were made, every e would not only look the same wherever it appeared on a page, but also occupy exactly the same amount of space. These constraints of consistency and repeatability meant that the makers of type developed styles and conventions, establishing a canon of established letterforms. But this canon was capable, over the centuries, of considerable development and variation.

The way that a designer of letters worked has not always been the same as it is today. Drawing, by hand or by computer, is the primary skill of a contemporary designer. The production of Roman inscriptions did involve the drawing of letters, and early printers copied the letterforms they used from pen-drawn scribal examples. But to make metal types, which were three-dimensional objects, the necessary skill was not drawing, but carving or engraving. From the fifteenth to the nineteenth century the person who designed letters was the punch-cutter. The first punch-cutters were, like Gutenberg, goldsmiths and other craftsmen used to fine work in metal. They had the tools and the skill to sculpt punches,

tiny model letters that were exactly the same size as the intended pieces of type. Punches were the start of the entire process. Each punch was cut from steel, which was then hardened and driven into a soft piece of copper to produce a matrix (Figure 4).

The matrix was fitted on to an adjustable two-part mould, which was shaped to cast an exactly rectangular piece of type, with the face—the shape of the letter determined by the matrix—at the top. The mould had to be adjustable so that any width of letter from a narrow i to a wide m could be cast to the correct width. Molten type metal—an alloy of lead, tin, and antimony—was poured in through a funnel at the top of the mould. Type metal cools and solidifies very quickly, so that the mould could be split apart to release the cast piece of type. All successive printing technologies are based on this fundamental concept of a model letter (whether metal, photomechanical, or digital) from which identical characters to be composed into text are made.

The invention of printing did not, by itself, change the shapes of letters. The first printed books in northern Europe appeared in Gothic black letter, and their pages resembled manuscript pages as closely as possible. These design decisions meant that books produced by the new technology followed the expectations of their mainly ecclesiastical readers. But when printing was established in Italy to produce books for the humanist revival of learning, these printers also turned to the revived antique forms. Again, there

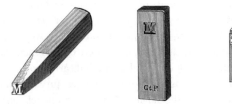

4. Punch, matrix, and cast metal type, from Marder, Luce & Co., *Illustrated Type Making*, 1880.

ıento ut cætera uidemus animalia ferri exi
ıriaſq̧ figuras & formas gradiés inuoluto ı
·leritatem greſſu facillime præſtat. Longæı
·tā cum pelle deponens reiuuenefcit:fed cı

fiat (ſi potero) ,q̄ potero , diligenter .
B. P. Immo Hercle fiat potius; eti-
am id ſi facere ipſe , ne fiat, potes: non
enim impedio : illud autem ideo dixe-

5. (*top*) Nicolas Jenson's roman, 1470; (*bottom*) the *De Aetna* roman cut by Francesco Griffo in 1495–6.

was a period of experiment, and one can see hybrid letterforms in the printing of Sweynheym and Pannartz, who introduced printing to Italy from Germany in the 1460s. From 1470, inspired by the work of the Venetian printer Nicolas Jenson (1420–80) and punch-cutters such as Francesco Griffo (1450–1518), who copied scribal hands, the antique letters began to dominate in southern Europe (Figure 5). It became the normal form of roman type that we recognize today, although it took some time to displace Gothic black letter in England, and even longer in Germany and Scandinavia.

Divine proportions

Scribes and printers in the Renaissance were faced with two competing pressures when designing their letters—should they be ruled by geometry or by the eye? There was a general belief, throughout the artistic and scientific worlds (which of course were then not as separate as they are today), in divine proportion—a fundamental set of geometric relationships that could be found in nature, in mathematics, and even in man. This belief is most memorably demonstrated by Leonardo da Vinci

(1452–1519) inscribing a human figure in a circle, inspired by the ideas of the classical architect Vitruvius (b. *c*.80 BC). These relationships represented perfection, because of their regularity and scalability—they seemed to relate man to the cosmos, and man's mechanical and intellectual endeavours to nature, and therefore to God. So it was not surprising that letterforms came in for the Vitruvian treatment of being forced into circles and squares.

Looking at these efforts now, we can see that, in the best examples, the letterforms come first, and the construction lines are created around them. Creating letters from shapes that are entirely regular, and building them on a genuinely geometrical frame, causes optical problems. A circle appears smaller than a square when both are the same height, and a horizontal line appears thicker than an identical vertical one. And because beauty was, after all, recognized as an attribute of God in the Renaissance, there was a counter-argument to geometrical construction, notably made by the lettering master Giovan Francesco Cresci (*fl*. 1539–1607), that the eye rather than measurement should be the arbiter of beauty. In other words, letters should be freely drawn and follow the best antique models in order to look beautiful.

Letters without serifs

The desire to make letters perfect is a recurring theme in the history of typography. In the 1920s, designers associated with the 'new typography' movement and the Bauhaus design school sought a radical approach to rid printed language of clutter, and make it suitable for a new, mechanical age. Out would go decoration and ornamentation. In would come a new aesthetic based on elemental geometric forms. And all excretions on letters would go too—including the serifs, the terminal marks on printed letters that were the residue of the terminal strokes of the scribe's pen or the letter-cutter's chisel. Letters without serifs—'sans serifs'—were not new. The type historian James Mosley points out that Greek

and Roman republican inscriptions lacked serif-like terminals, and in the vogue for the antique in eighteenth-century England such forms had been revived by architects with an antiquarian interest, such as John Soane (1753–1837). Nineteenth-century commercial printing was awash with sans serif letters, but from a twentieth-century point of view these were rarely designed on rational principles. Nineteenth-century sans serifs were workhorse typefaces, often made at very large sizes for advertising; boldness and impact were everything.

But it was the idea of elemental, skeletal forms, pared to simplicity, that appealed to twentieth-century designers whose hero was the engineer. As many of these designers were German, and Germany was still a bastion of Gothic black letter type, and the German language used (and still uses) capitals far more freely than other European languages, their revolt was total. They sought to abandon heavily capitalized black letter text, and use only a single alphabet of lower-case letters based on geometric construction with ruler and compasses. These exercises in minimalism were widespread: avant-garde European typographers such as Jan Tschichold (1902–74) and Herbert Bayer (1900–85) drew such alphabets and promoted them in their writings. But the removal of capital letters and reliance on the fully geometric letter was never more than a project for the avant-garde. The typeface that most fully reflects the aims of modernist lettering, Futura, is actually a careful balancing act between truly geometrical and optically corrected forms. At the points where circles abut straight strokes, the stroke thicknesses have been reduced to avoid concentrated areas of visual weight. And of course Futura has a full complement of upper- and lower-case letters (Figure 6, p. 12).

A less ideological approach to letterforms had produced another stripped down, skeletal design a decade earlier, when the calligrapher Edward Johnston (1872–1944) created his 'block letters' for the London Underground in 1916. Johnston was associated with the Arts and Crafts movement, and was a pioneer

in recreating and teaching traditional penmanship and calligraphy. He came to what he called 'essential forms' for a practical reason—they were to be foolproof letters, their strict proportions and geometric relationships making them easy to reproduce by signwriters with minimal variation all over the capital's transport network.

Johnston's model was followed by his pupil Eric Gill (1882–1940) when he came to design his sans serif typeface family Gill Sans for metal typesetting, which was issued from 1928. While Gill also rationalized his letters into squares and circles, redrawing them as compositions on graph paper, the shapes of his lower-case letters are based on pen-drawn forms, not circles and squares. The adjustment of stroke weights, present in Futura, is even more widespread in Gill Sans, for example in the a and e. In part, this is because Gill was designing letters to be used at normal text sizes where such optical compensation is essential, while Johnston was designing letters to be seen in large sizes and at a distance on signs and posters.

JOHNSTON 123456789
abcdefghijklmnopqrst

FUTURA 1234567890
abcdefghijklmnopqrstuv

GILL SANS 1234567890
abcdefghijklmnopqrstuvw

6. Johnston (originally designed in 1916), Futura (Paul Renner, 1927), and Gill Sans (1928), shown in current digital versions.

Johnston wrote about the 'essential or structural forms of letters' as 'the simplest forms that preserve the characteristic structure, distinctiveness, and proportions of each individual letter'. Another way that type designers make perfect letters is by aiming for uniformity of design: constructing them from a common vocabulary of shapes, so that an alphabet of letters hangs together stylistically, in what Tschichold described as 'the comfortable recognizability of thoroughly distinctive yet congruent letterforms'. Chapter 7 will explore how these ideas relate to our psychological understanding of the reading process and the legibility of type.

Spareness, simplicity, and standardization define much that we consider modern, or modernist, in typography. And so the sans serif, which in the early nineteenth century was considered antique and exotic, became associated in the twentieth century with the new scientific, technological age; a shift in perception that demonstrates how letterforms, although in many ways arbitrary, can nonetheless be associated with cultural values.

More recent ideas about letter construction

Ideas from the world of computing and the world of lettering have informed more recent ideas about letter construction. The development of computers and printers that needed to store type as data rather than in a physical form was one influence. The subtlety of the curves and stroke widths of printed type could not be rendered by the large pixels of early digital screens and printers. A geometrical approach was used to reduce letters to bitmaps, so that characters became patterns of dots on a fixed grid, often of exactly the same width. At the time, fixed-width alphabets were familiar to readers because of the influence of the typewriter and, as with the mechanical constraints of the typewriter, the underlying pixel grid gave little scope for variation in design. A dramatic experimental response to this kind of regularized letterform—'over-the-top and never meant to be really used', according to the designer—was Wim Crouwel's New Alphabet

of 1967. Not a true bitmap font, it consisted only of horizontal and vertical strokes, with elegantly chamfered corners, and raised the question of whether a new kind of machine aesthetic in typeface design was required for new production circumstances. The earliest typefaces on the Apple Macintosh computer (1984) were rendered on screen as bitmaps, and another set of experimental bitmap designs, much more legible than Crouwel's, were created by the designer Zuzana Licko for *Emigre* magazine from 1985. Technologies that enabled typefaces to be rendered with less obvious on-screen pixelation were quickly developed, but Licko's early bitmap typefaces confirmed designers in the view that typeface design for the new age of desktop computing did not need to follow traditional print designs slavishly.

Another idea about letterforms that has influenced type designers today was articulated by the American designer William Addison Dwiggins (1880–1956). A skilled theatrical puppet maker as well as a type designer, Dwiggins recognized that the exaggeration of facial features required for successful character designs in puppetry had an equivalent in type. Rather than design letters with gentle transitions between curves and straight lines, Dwiggins applied what he called the M (for marionette) formula of exaggeration, so that, for example, the curve at the top of an n would meet the right-hand vertical stroke at an abrupt angle. This way of opening up the internal spaces of letters by using straight lines and sudden transitions was adopted by designers working the 1980s and 1990s, who were producing typefaces for low- and medium-resolution laser printers. It remains a common feature of designs intended for screen use today.

While bitmaps reduce letters to collections of squares or circles, and the M formula is a way of thinking about the outlines of letters, type design was also influenced by ideas about how a writing tool makes a stroke, and how that stroke is modulated by manipulation of the tool to produce letters. These ideas were stated separately by the mathematician and computer scientist Donald

Knuth and the teacher of lettering Gerrit Noordzij. Both envisaged a tool that has particular characteristics. These determine the thickness of the strokes it makes, and the way that it can change the thickness of the strokes either through the application of pressure or through the angle at which it is held. Noordzij, thinking of a physical tool, chose this model because he wished to stress the primacy of written forms in typography—a standpoint that is not without its critics, who believe that over the centuries type design has developed its own conventions separate from handwriting. Knuth, thinking of a virtual tool, chose the model to enable him to develop a device-independent way of creating letters on screen. If the notional pen, for example, had a circular 'nib' that was not capable of expansion, the letters it would 'write' on screen would be letters of uniform thickness; a nib capable of expansion would write letters with thicks and thins. The angle at which such a pen was 'held' would determine where the thickest parts of a circular letter such as o would lie.

The key aspect of this model is that the designer establishes the parameters and behaviour of the tool that produces letterforms from a sequence of strokes, whether this is programming of a physical or virtual kind. Knuth's implementation of this idea was the type creation program Metafont; Noordzij's writings included influential diagrams that showed how, through controlled changes in parameters along different axes, two- or three-dimensional matrices of related designs could be generated. The extreme parameters of the tool lie at the corners of the matrix. A three-dimensional matrix could have axes of weight, of stroke contrast (the difference between thicks and thins), and angle of stroke. This view of the morphology of type designs was influential when designers came to consider the creation, not just of individual alphabets, but of whole families of related letterforms.

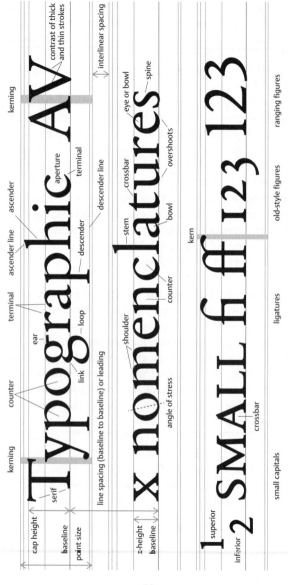

7. Nomenclature of type.

The following labels appear in the figure:

- kerning
- contrast of thick and thin strokes
- interlinear spacing
- kerning
- cap height
- serif
- baseline
- point size
- ear
- counter
- terminal
- ascender line
- ascender
- aperture
- link
- loop
- descender
- terminal
- descender line
- line spacing (baseline to baseline) or leading
- x-height
- baseline
- shoulder
- stem
- crossbar
- eye or bowl
- spine
- overshoots
- bowl
- counter
- angle of stress
- kern
- superior
- inferior
- crossbar
- small capitals
- ligatures
- old-style figures
- ranging figures

Typographic AV

g

x nomenclatures

1 2 SMALL fi ff 123 123

16

Chapter 2
Practical letters

Written communication cannot rely on only one style of letter to function. A single alphabet might suffice if we are looking at Roman inscriptions or even signs on the London Underground, where simple declarative statements—*Divo Tito* (to the divine Titus), or *Way Out*—are the norm. But if we look at any kind of modern publication, we see a variety of letterforms coexist. The headlines and text of a printed newspaper need to be distinct and on web pages links have to stand out—a typographic monoculture cannot support the variation and differentiation that we require for effective reading. Shopfronts, branding, and advertising show the great variety of letters that can evoke different expressive or emotional associations in the reader's mind. The great strength of the Latin alphabet is its ability to be modulated typographically—that is for a basic design to be varied by slope (upright or slanted), weight (light or heavy), compression (narrow or wide), and even by the addition of decoration. In this way a related (or contrasting) set of designs can provide all the 'speaking parts' of a complex page.

Typographic terminology

This concept of related alphabets is central to contemporary typeface design, but to look at this in more depth requires a discussion of terminology. Over the past forty years, computer

applications have popularized the word font, but designers find this word ambiguous. A font was originally a set of metal types of one particular design and size, the word denoting the process of casting or founding. In the 1980s, the way that alphabet designs were stored on computers was analogous: there was a separate font file for every different design variant at every different size. This is no longer the case, and the term is now commonly used to mean a design—'use the Helvetica font'—more often than to refer to the file on a computer that holds the digital information for it. But, by itself, the word font does not make it clear if it refers to a whole group of related designs—for example, Helvetica in all its versions—or just one specific variety of that design—for example, just Helvetica Bold. While it is perfectly correct to talk of fonts when referring to computer files and technologies, using a more traditional terminology helps us to a better understanding of the design principles behind type design, and to be more precise when discussing type.

In the middle of the hierarchy is the typeface: a family of alphabets related by design and produced by a single manufacturer. Each typeface consists of variant fonts, usually roman, *italic*, **bold**, and ***bold italic***; and sometimes other variants: condensed and **expanded**, lighter and **heavier**. Several manufacturers may make versions of the same typeface design that differ in design details. Each font contains a collection of characters, a complete matching set of capitals and lower-case, numerals, punctuation and other signs, known as the character set for that font. Some fonts have a limited character set (capitals only, for instance) or an extended character set which includes characters with the accents and diacritics required to set many languages. At a level above the typeface comes the typeface family, which can embrace a number of parallel typefaces, usually serifed and sans serif. Frutiger is one such example (Figure 8), and the Rotis and Stone families include serifed, semi-serifed, and sans serif typefaces. Sans serif designs lend themselves to more extreme variation in weight and width than serifed designs.

		type	*type*		
		type	*type*		
type	*type*	type	*type*	type	*type*
		type	*type*		
type	*type*	type	*type*	type	*type*
type	*type*	type	*type*	type	*type*
type	***type***	type	*type*	type	*type*
type	***type***	type	*type*	**type**	***type***
		type	***type***		
		type	***type***		

8. **Part of the range of variant fonts available in the Frutiger Serif Condensed, Frutiger Neue, and Frutiger Serif families.**

Just as the letters we use on digital devices are designed on the same principles as the metal letters used for printing, the names used for parts of letters have historical origins. A type's 'face' was the surface designed to be uppermost in a press, receive ink, and create an impression on the paper. The most significant aspects of a letter's design are: the relationship of the main part of each letter, known as the x-height, to the overall height of the letter (its appearing size); the difference between the thickness of strokes that make up a letter (its contrast); the angle at which thick strokes change into thin strokes (its angle of stress); and the openness of letters such as a, c, e, and s (its aperture). Figure 7 (p. 16) shows some of the terms used to describe parts of letters and their appearance.

The development of typefaces

We saw that the humanist scribes of the Renaissance developed two related scripts, one upright, one with a slope. The upright form of the antique letter became the model for the first 'roman' types. But the role of the sloped form, which we call 'italic', as a companion to roman, did not come about immediately. The first italic type was made in Venice for Jenson's successor Aldus Manutius (*c*.1449–1515) by Francesco Griffo, and was first used in 1500. It was subsequently used, instead of a roman, as the text type for Aldus's small-format series of classic texts. Its narrowness had a space-saving function, and also reflected the letterforms that readers would have encountered in manuscript versions of these texts. The italic style was initially a variant form of lower-case—Aldus used small-size roman upright capitals instead of sloped ones—but sloped capitals of normal height relative to the lower-case were soon developed. Slope is not the only important distinguishing feature of italic type; the cursive nature of the style, that has its basis in rapid handwriting, is also important. Italic letters, being constructed of fewer separate strokes than roman ones, tend to have entry and exit strokes rather than serifs; and they are normally narrower than the equivalent roman. Italic type is also amenable to the addition of decorative flourishes, and these are known as swash letters.

It was printers such as the Parisian Robert Estienne (1503–59) who began to use both the roman and italic forms together in the way we do now, to indicate respectively normal and variant text. In doing so they unleashed the enormous power of the Latin alphabet: its protean quality of allowing modulation in a variety of ways. In his *Dictionaire francoislatin* (1539), Estienne systematically used italic type for words in French, and roman for their Latin translations. This led to the requirement that roman and italic types should be compatible, so that they matched in size and weight. From around 1520 smaller-than-text-size capitals began to be used for further differentiation within text, leading

to the development of related small capitals. This five-alphabet system (roman CAPITALS and lower-case, *italic CAPITALS and lower-case*, and SMALL CAPITALS) would provide the basis for typography for the next three centuries.

The punch-cutters of the sixteenth century worked for an international market, and Claude Garamont (*c.*1480–1561) achieved fame across Europe, cutting Latin and Greek types in a wide range of sizes. (It is likely that he spelt his name thus; contemporary typefaces called 'Garamond' reflect a later spelling.) The types made by Garamont had a characteristic style, but we should not think that he created a 'typeface' or a 'font family' as we understand it today. The process of punch-cutting was entirely done by hand, and each size of type was independently produced. Punch-cutters therefore made optical adjustments to ensure that each size was optimized for both casting and printing. This process, called optical scaling, normally meant that smaller sizes were generally heavier, with less contrast between thick and thin strokes, strong serifs, larger x-heights, and more inter-character space. Larger sizes would correspondingly be narrower, with lighter strokes and serifs, longer ascenders and descenders, and tighter character spacing.

Changes in type design reflect technological change and also changes in the way that we produce and read printed matter. The relationship between the development of forms of communication and the letterforms used in them is seen in the Netherlands in the sixteenth and seventeenth centuries. Dutch innovations in publishing, such as the newspaper, demanded a new kind of design: the types of Hendrik van den Keere (*fl.* 1570) and later Nicholas (Miklós) Kis (1650–1702), were strong and economical. Compared to earlier types, they had a greater contrast between thick and thin strokes, and the x-height was proportionally larger. The letters were also narrower and produced a darker page, a feature that was possibly more acceptable to readers in northern Europe who were still accustomed to black letter.

The next steps in the history of type design takes us back to France, and to the beginnings of the Enlightenment. In the 1690s, under the auspices of the French Royal Academy of Sciences, a new approach to making type was developed. Instead of being solely the work of punch-cutters, a set of types was based on new alphabets devised by a committee appointed by the Academy. This design (known as *romain du roi*, the king's roman) was conceived as an ideal alphabet, with each letter positioned on a background grid to emphasize its geometry and define its construction (Figure 1, facing p. 1). The letterforms were a departure from previous models: like Dutch types they showed a greater contrast between thick and thin strokes, but to this was added a smoothness in the drawing of curves, a delicacy of serif treatment, and more generously proportioned ascenders and descenders. The angle of stress was also different from that of preceding types. Griffo, Garamont, and others had reproduced the oblique angle of a broad-nib pen when cutting letters such as o and e, with the thickest parts of a curved letter at 45° and 225° from the vertical. The *romain du roi* designs made the angle upright, so that strokes are at their thickest at 90° and 270°. The italic lower-case showed the influence of new styles of Italian and French calligraphy, which had replaced the narrow, almost upright style (called chancery), on which Aldus's italic had been based, with a more open, flowing style. Italic capitals were simply upright capitals slanted.

Although these 'perfect' letters ignored some aspects of practical type design (for example, circular letters were drawn without overshoots, the slight vertical enlargements at top and bottom relative to square letters that are required to make them visually equal in height), the types that were made from them influenced the course of type design over the next two centuries. The committee's designs were first presented as large-scale engravings, many times larger than the final types; it is therefore the first type for which a preliminary design is known to have been made. However, at this time there was no mechanical way to transfer

such precise dimensions direct to a tiny, hand-cut punch, so that punch-cutters such as Philippe Grandjean (1666–1714), who actually produced the types, had to interpret the designs visually, and apply the necessary optical correction to the different sizes.

The invention of printing did not mean the end of handwritten documents. The manuscript book was almost entirely replaced by the printed book, and printing enabled new formats such as the magazine, but commerce, government, law, and the Church relied on handwriting until the practical implementation of the typewriter by Remington and others in the 1870s. As literacy was a mark of social status, a good 'hand' was also a desirable attribute for the aristocracy and an aspiration of the middle class. (An Elizabethan example of fine calligraphy as an indicator of social rank and influence is the exquisite book of psalms (1599) by Esther Inglis (1571–1624), where each psalm was written in French and English in a different decorative style, for presentation to Elizabeth I in order to gain favour for Inglis's husband at court.) Formal handwriting continued to influence type design.

Letterforms engraved on metal for printing or on stone for inscriptions began to develop a rounder, more flowing style, influenced by the changes in penmanship. The broad-nib pen style of the Renaissance, with a sharp contrast between thick and thins, and an oblique angle of stress, had been modified in the baroque period to a more flowing style associated with Cresci. The development of the flexible steel nib in the eighteenth century allowed a smoother transition between thick and thin strokes, and English writing-masters such as George Bickham (1684–1758) and George Shelley (c.1666–c.1736) excelled in this style. Writing-masters produced books of alphabets to train clerks and other professional writers, and to teach handwriting as an accomplishment. The increased contrast and smoother curves and transitions of their letterforms were in marked contrast to type designs then in widespread use, such as those of William Caslon (1692–1766), which were based on older Dutch types.

The new styles of handwriting influenced type design through the work of the Birmingham writing-master and printer John Baskerville (1706–75). The types that John Handy cut for Baskerville's press in about 1750 adopted the features of the writing-masters' letterforms, and can be seen as precursors of a more radical rethinking of the shapes of printed letters some forty to fifty years later.

Types developed around the turn of the nineteenth century in France by the Didots and in England by Robert Thorne (1754–1820) show a shift away from the oblique stress and angled serifs of the types of Jenson, Griffo, Garamont, and of the later Dutch type founders (and which we now term 'old face'). These new 'modern' types followed the *romain du roi*, and had flat, often hairline serifs, vertical stress, and more abrupt shading from the thick to the thin parts of the letters (see Figure 21, p. 124). The letterforms were still based on hand-made originals, but resembled the style of letters on engravings and tombstones, and the handwriting of contemporary writing-masters rather than that of Renaissance scribes. As the nineteenth century progressed, the appearance of text changed rapidly, with the new types driving out the old.

Points to pixels

Perhaps as far-reaching as these changes in letterforms was the reconsideration of the relationships between sizes of type, in which the *romain du roi* set an important precedent. All previous sizes of type had been individually created, with no exact mathematical relationship between them, or indeed to any standard unit of measurement. The *romain du roi* types were planned to fit into a scheme of sizes related to the *pied du roi* (the official French foot, just under 325 mm). The *pied du roi* was divided for this purpose into 1728 units, and the dimensions of the types were based on this unit, which was just under 0.2 mm. This allowed for a rational series of sizes, in present-day terms ranging from about 4 point

to 100 point, consisting of five groups of four sizes. Within each group there was a regular percentage increase in size; and each group was twice the size of the previous one.

This system was a precursor of the point systems later developed by Pierre-Simon Fournier (1712–68) and François-Ambroise Didot (1730–1804), the latter being generally adopted in Europe. The point system used by printers in Britain originated in one adopted in 1886 by twenty-four type foundries in the United States, some of which later merged to become the American Typefounders' Company (ATF). Because ATF effectively had a national monopoly of type production in the United States, this definition of the point (abbreviated to 'pt'), equal to 0.013837 inch or 0.3514598 mm, became a national standard. Most important British type founders began using it in 1903. With the spread of digital typesetting in the 1980s, the PostScript point (exactly 1/72 inch, approximately 0.35278 mm), became the international standard for typographic measurement, replacing a number of national variants.

The point has, somewhat surprisingly, retained its position as the way of measuring type for print in the digital age, as attempts to metricate the printing industry in the twentieth century failed to get off the ground. The term pica is still used for a horizontal or vertical dimension consisting of twelve points—the print edition of this book has a column width of 20½ picas, or 20p6 in shorthand. In print terminology, an em is a horizontal dimension equal to the type size (so a 10 pt em = 10 pt, and an 8 pt em = 8 pt); an en is exactly half an em (so a 10 pt en = 5 pt). The use of a numerical system to describe the relationships between letter sizes is fundamental to modern typography. Typography has been described as 'a grid', to acknowledge that Gutenberg's fundamental invention enabled the assembly of mass-produced letters in an endless variety of ways, because of their regular, modular relationship. The text lines in the print edition of this book are 12 pt apart, measured from baseline to baseline, and the headings are designed so that the depth of the heading itself, plus the spaces

above and below it, add up to 36 pt, an exact multiple of 12 pt. You can check this by holding a page up to the light.

Paper sizes are not defined in picas and points, and this raises the question of which units should be used for page elements (margins, gutters, column widths): should they be in millimetres/ inches, or in picas and points? Practice varies, but the usefulness of working in picas and points is that the modular relationships of type sizes and vertical spaces are much easier to plan and check.

For on-screen use, the preferred terminology used by cascading style sheets (CSS) is more complicated. While there is always an absolute relationship between a specified dimension and the appearance of that dimension on a printed page, the same cannot be said of screen displays, where pixel resolutions differ from device to device. To overcome this, the 'pixel' (abbreviated px) is arbitrarily defined as 1 px = 1/96 inch (approximately 0.264583 mm), and may or may not equal one physical device pixel. While px is an absolute unit, the more widely used em, like its metal namesake, is a relative one, equal to the nominal size of the current font. A 1 em indent in a paragraph set in 16 px will be 16 px wide, one that is 1.5 em will be 24 px wide, and so on. If a page uses multiple font sizes, the root em (rem) can be used to define the basic font size that is declared at the start of the page. Using rem to define paragraph indents, for example, will allow them all to be equal in width whatever the font size of the paragraph. Responsive design—the predetermined alteration of on-screen layout and sizes to match the physical size of the device—relies on the use of these relative dimensions.

Complex text typography

If we look at Samuel Johnson's *Dictionary of the English Language*, published in 1755, we see a relatively complex text presented in a relatively plain way (Figure 9). The printing

historian Michael Twyman distinguishes between intrinsic and extrinsic features of a piece of typesetting. The intrinsic features are those to do with the size, shape, or character set of the type used; the extrinsic with the things that can be done with those given letters, such as their arrangement in lines, paragraphs, and pages. The Caslon type in which Johnson's *Dictionary* was set was widespread in England at the time, and its design is firmly in the old face tradition. The five related alphabets (roman and italic, in both upper and lower case, and small capitals) were the only variations for setting text that the printer had. The printer has not differentiated the text by using different sizes, so the intrinsic resources are limited: capitals are used for headwords and italics for sources. It is only a clever use of indentation and alignment, which are extrinsic arrangements of the type, rather than the intrinsic use of variant letterforms, that tells the reader that a paragraph is a quotation rather than a definition.

CE'REMONY. *n. ʃ. [ceremonia, Lat.]*
1. Outward rite ; external form in religion.
 Bring her up to the high altar, that ʃhe may
 The ʃacred *ceremonies* partake.　　　*Spenʃer's Epithalamium.*
 He is ʃuperʃtitious grown of late,
 Quite from the main opinion he held once
 Of fantaʃy, of dreams, and *ceremonies.*　　*Shakeʃp. J. Cæʃar.*
 Diʃrobe the images,
 If you find them deck'd with *ceremony.*　　*Shakeʃp. J. Cæʃar.*
2. Forms of civility.
 The ʃauce to meat is *ceremony*;
 Meeting were bare without it.　　　*Shakeʃp. Macbeth.*
 Not to uʃe *ceremonies* at all, is to teach others not to uʃe them
 again, and ʃo diminiʃh reʃpect to himʃelf.　　　*Bacon.*

ma'am /mɑːm, mam, *unstressed* məm/ *noun & verb.* L17.
[ORIGIN Contr. See also **MARM, MAUM, MUM** *noun*[4].]
▶ **A** *noun.* Also (*colloq.*) **'m** /(ə)m/.
　1 Madam. Chiefly as a respectful form of address: now usu. to a member of royalty or to a superior officer in the women's armed forces, but formerly used more generally to any (esp. married) equal or superior. L17.

　　DICKENS 'Mrs Sparsit ma'am', said Mr. Bounderby. 'I am going to astonish you.'

　THANK-YOU-ma'am.
†**2** A person addressed as 'ma'am'. M–L18.
▶ **B** *verb trans.* Address as 'ma'am'. E19.

　　G. R. SIMS Don't ma'am me—I'm a miss.

9. Johnson's *Dictionary*, 1755 (*top*), compared with a modern dictionary entry, 2007, set in variant fonts of two typefaces.

If we look at the modern dictionary example in Figure 9, we can see that almost every element within it can be distinguished by an intrinsic feature of its typography. Words are set in more than one typeface. We can easily discern two type families, one serifed, one sans serif. The serifed type is used for the actual definitions. The sans serif is used, heavily emboldened, to make the words being defined stand out, and, in different weights, to indicate grammatical information and annotation. Paragraphing, indenting, and vertical space, all extrinsic features, allow an entry to be divided into parts and for entries to be separated from one another. These visual distinctions guide us through the information in the dictionary. Contemporary typefaces have a greater range of intrinsic resources that can be exploited to differentiate parts of text, and these typefaces can work together with enhanced extrinsic features, such as tint panels, to assist the reader's understanding.

The modern dictionary uses bold-face and sans serif type, two innovations that emerged from the enormous expansion of typographic resources that began at the end of the eighteenth century, and which changed typography utterly. This expansion, most dramatic in the early part of the nineteenth century, was in response to changes in the quantity and nature of printed matter. Before this, printing really meant book printing, and types were made for bookwork, or magazines and newspapers that still resembled books. Now there were many more genres of printed material, and, as printing changed, so did the design of type.

The sans serif, as we saw, dates from the late eighteenth century, when it was created in the wake of the renewed interest in antiquarianism, and particularly with the ancient civilizations of Egypt. Indeed, on its first appearance in a Caslon foundry type-specimen book of 1816 it was called 'Egyptian'. Bold-face types appeared in Britain from the 1810s, and developed two basic forms. One approach was to thicken all parts of the letter, including the serifs, which then became a dominating feature

10. New types developed in the early nineteenth century: a poster of 1832.

of the design: these were the slab-serifs, also confusingly called Egyptians. This name stuck to the slab-serif types, and the sans serif types became known as 'grotesques', following the designation of William Thorowgood (d.1877). Contemporary writers ascribed this development to Vincent Figgins (1766–1844) or Robert Thorne. The other was to over-thicken only the parts of the letter that were normally slightly thicker. This thickening could be taken to an extraordinary degree, resulting in the 'fat face' developed by Robert Thorne. All these types were strong enough to be read from a distance, and so could be used at very large sizes on advertising posters (Figure 10); early examples were the publicity for Vauxhall Gardens in London from the 1820s, and for the enormously popular lotteries of the same period.

But these typefaces were not really suitable as companions for ordinary roman and italic; they were designed to dominate. As a result, narrower, less heavy bold-face types, usually known as

Clarendons, were introduced to work in text in 1845 by Robert Besley (1794–1876). These new bolder designs coexisted with normal roman types for the next hundred years. Nineteenth-century printers became adept at combining these various roman, bold, and sans serif types, although the visual features of the styles were quite different. Combinations of types enabled the important parts of a document to be emphasized, aiding the reader's navigation through the text. At one extreme are circus and theatre bills that brilliantly combine all kinds of letters in a playful profusion. But there were also many carefully thought-out pieces of information printing, such as railway timetables and school textbooks that used several typefaces of different styles and weights together in a way that emphasized the structure of the text for the reader.

Other fertile areas for the development of letterforms in the nineteenth century had nothing to do with metal types: these were the letters designed for lithographic printing and the often exuberant letters used by the makers of commercial signs, especially shopfronts. Lithography, a printing process completely separate from letterpress, involved drawing the design to be reproduced on a stone printing surface. Metal typesetting and letterpress involved the combination of precast pieces of type in geometrically regular arrangements, but every piece of lithographic printing was drawn afresh on the stone, so there were no constraints on how fanciful or complicated letterforms could be, and they could be set out along curves, at angles, and in irregular shapes. And through the process called chromolithography (printing from multiple stones in exact register) they could even be in full colour, which was still impractical for letterpress. Chromolithography was particularly suitable for work such as sheet music covers, advertising placards, and packaging, and it allowed the development of all kinds of allusion in design, especially as letters could easily be combined with colour illustrations. Letters could be made to resemble icicles, or trees, or appear to be blown around by wind or waves; when

all things Japanese were fashionable in London in the 1880s, it was easy to make Latin letters out of brush strokes that imitated Japanese calligraphy. Chromolithographers also published portfolios of lettering for use by signwriters and designers of shopfronts, often depicting *trompe l'œil* three-dimensional effects. These and other hand-drawn lettering styles would become the basis for a variety of display types for use at large sizes in advertising. At first made in metal, from the mid twentieth century display types were made profusely for phototypesetting and then as digital fonts.

The mechanization of type

All of the types we have considered so far were essentially made and then set into words by hand. Punch cutting, type founding, and hand composition were laborious and skilled work, so it is not surprising that in the nineteenth century much effort went into mechanizing and deskilling manual processes in the type-making and printing industries in order to reduce costs and increase productivity. There were various inventions that mechanized aspects of type manufacture, leading to the invention in the 1880s and 1890s of two practical ways of mechanizing type composition, the Linotype (*c*.1886) and the Monotype (*c*.1897). These machines combined the hitherto separate manual tasks of casting the type and assembling it in lines, and enabled every job to be printed from type freshly made and composed in one operation.

The Linotype and Monotype had enormous ramifications for typography generally, but crucially the types they made had to be designed in a new way. Instead of being essentially handwork, the production of type began to be carried out in the same way as other aspects of industrialized engineering. There was a return to drawing, but drawing that was very different from the work of those who laid out letters to be cut in stone in ancient Rome or the scribes in medieval monasteries. Engineering drawings were now required for every letter or other character that was to be

made, to guide the mechanical cutting of punches, and thereby the production of matrices and type.

These type drawings, done at a large scale that was far removed from the one-to-one scale at which punch-cutters worked, were created by drawing-office staff who understood the tolerances of the machines for which they were providing instructions. Decisions about measurements and proportions, previously made by eye, were systematized. It became necessary to plan combinations of typefaces with great care, as both the Linotype and Monotype systems imposed (different) dimensional constraints on the type they could produce. The first type drawings for mechanical type-making at the end of the nineteenth century were created by tracing from enlarged images of actual types, and it was not until the early part of the twentieth century that new and original designs were conceived, first as drawings and then translated into type. Drawing—albeit in a technical, controlled way—remained the necessary skill of a type designer throughout the twentieth century, until the development of digital processes in the 1980s provided new tools for the creation of type that would only have a virtual, and not a physical, existence.

These changes and constraints reinforced the move, started by the remaining founders of hand-set type, towards the development of families of related designs, with common design features and dimensions. The development of phototypesetting in the period immediately after World War II accelerated this process. Instead of casting metal type, this process involved exposing light through a photographic negative of each character on to film or sensitized paper to create lines of text. (Later a digitally stored image flashed on a cathode-ray tube replaced the negative.) Mechanical composition was limited by the number of matrices for different characters that could be held on the machine at any one time: normally 180 on a Linotype, up to a maximum of 272 on a Monotype. In comparison, a typical photocomposition system of the 1970s (the Linotype V-I-P) could be equipped with

576 characters, rising to a maximum of 1,728. Removing the constraint on the number of characters and typefaces that could be accessible at any one time encouraged the development of larger families of related fonts, so that it became normal for most typefaces to consist (at the very least) of a related roman, *italic*, **bold**, and ***bold italic***. This became even more firmly established with the development of digital type in the 1980s; so much so that a design without these four 'normal' variants is seen today as something of an oddity by the ordinary user of computers and word-processing software. Font storage is now trivial: today, a single 1,024-character digital font occupies less than 200 kilobytes of computer memory, allowing any system to have hundreds of multi-font typeface families available simultaneously.

Types for text, types for showing off

As soon as type manufacture moved away from creating metal types, new influences could bear on type design. Phototypesetting had an expansive effect on type design similar to that of lithography in the nineteenth century. Type manufacturers were now able to create new designs much more quickly, and printers could install more typefaces more easily than it would have been practicable to when every new case of metal type took up space and literally weighed down the composing room. Display phototypesetting firms in large cities were able to offer a quick-turn-round service for advertising agencies, setting headlines in a matter of hours from a range of hundreds of typefaces with many variants.

All these typefaces were still originated from hand-drawn originals, of course, because technical letter-drawing skills were then widespread—the digital age has eliminated the large number of commercial lettering artists who worked for chromolithographers, film and television studios, department stores, and as signwriters. From the 1960s, rub-down transfer lettering offered a low-cost replacement for this handwork.

From the 1980s, cheap and widespread digital type applications made it easy to create one-off designs for custom use. The bulk of these are quickly produced display types with a limited character set, as types suited to continuous reading require a particular understanding of what constitutes a good working text design, and time and effort to design a large character set—especially if it is intended to support many languages.

The difference between large and small letters is not just one of linear scale. Traditionally, type founders applied optical scaling to types, that is they made the adjustments to weight, width, and spacing of letters that were necessary to make them clear at different sizes; this is still desirable today. Type for printing at small sizes eschews elegance for absolute clarity: it is relatively wide, and has a large x-height and open aperture. Type for printing at larger sizes has finer details, and is typically lighter and narrower. These differences are applicable to type for use on screen, and have been implemented in the fonts used in the interfaces of the Windows and Macintosh operating systems: a number of master sizes are designed for use at specific size ranges, and implemented automatically (see Chapter 7). For more general use, the Adobe typefaces Arno, Garamond Premier, and Minion have useful ranges of optical variants in every weight.

Drawing digital letters

Whether they are initially drawn by hand or created on screen, digital letters are described and stored as mathematically defined outlines, called Bézier splines. An outline consists of continuous lines called contours: h has only one contour that runs around the whole character; o has two, the outer contour that defines the overall shape and the inner one that defines the counter; g has three. Straight-line and curved components of a contour are defined by points positioned at each end of the component. The actual shape of a curve is controlled by moving off-curve 'handles' on the points that define it (Figure 11).

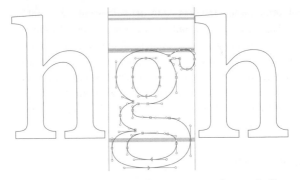

11. A digital character showing outline contours and on- and off-curve points. The grey lines are horizontal alignments that are common to characters across the font.

The reason for creating type in this way is to make it work with any digital device. The mathematical description of every character is scalable: it can be 'projected' on to any pixel grid on any display screen or printing device at any size or resolution that is required. The continuous outline and smooth curves of the character are then translated into the pixels of the rendering device. The character in the font is device- and resolution-independent; it is the rendering device which switches on the relevant pixels or lays down the relevant areas of toner or ink to create the image of the character. Fonts include programming called hints that makes characters fit very low-resolution pixel grids without producing awkward, irregular patterns of strokes. In the 1980s, it was this independence from specific devices that transformed type from the closed, proprietary systems of typesetting machine manufacturers into a tool that could be used universally on any computer.

Each font within a typeface is normally fixed in its design: it cannot, without distortion, be made wider or narrower, lighter or bolder. This means that a web page that contains a number of fonts needs to load them all before it can display the text, and it also means that type cannot be dynamically re-proportioned to fit screens on different mobile devices. The OpenType variable

font format, where the data-equivalent of several individual fonts is packaged into a single font file, seeks to remedy this. This is done by defining variations within the font that give instructions about how characters can be re-proportioned along defined axes up to certain limits. This allows designers to specify any instance within these limits. A bolder, narrow variant of the font can be specified for a small mobile device, and a lighter, wider variant for desktop use.

Lines of letters

How do letters sit side by side to make words and lines of type? The fixity of design that the metal matrix forced on types cast from it and the physical regularity of size of these pieces of metal are things of the past. First phototypesetting, and then digital type, allowed much greater control over the side-by-side placement of letters, but the letters still needed to be accurately measured. Because the em is a relative unit of measurement, digital type can be created at any size and scaled to any size. In the OpenType font format this is subdivided into 1,000 relative units. Each character can be a different number of units wide, and this width includes both the width of the character itself and the space allowances on either side (called sidebearings) that give the character space to breathe when it is set next to another. To judge these sidebearings, type designers test each character by placing it between pairs of round and straight characters, such as o and h (whose widths they have already defined), and adjust the widths accordingly to achieve a good 'fit'.

Digital characters do not need to stay within their own boundaries: parts of a letter can exceed the width allocated to it. For example, the ascender of an f or the tail of a Q is usually designed to overhang or undershoot the following character; this is particularly noticeable in italic fonts. Sometimes the widths allocated to characters will work for most combinations, but not for all. When these awkward pairs of letters are set together

(typical examples are VA and gy), an adjustment called kerning is made. The designer defines a table of kerning pairs so that they are respaced automatically by the type composition software, which adds or subtracts units to improve the fit of the character pair. For certain character combinations even kerning does not help, as they will always combine awkwardly. The solution for character pairs such as f followed by another f, an i, or an l is to replace the two characters with a combined form known as a ligature: fi, ff, or fl. These conventions of character spacing, kerning, and using ligatures help designers achieve a regularity of rhythm in a typeface design—most noticeably of vertical strokes—so that the predesigned letters can be set in ever-changing combinations and still present an even, regular texture. Some of the consequences of this regularity of stroke rhythms in typefaces will be discussed in Chapter 7.

Composition software, such as web browsers and page layout applications, uses the character widths of a font to arrange type into lines. From the earliest days of printing it has been normal for columns of type to be fully justified, so that both the left and right edges form straight lines. This involves varying the spaces between words, and often involves dividing words. The alternative style, known as unjustified or ragged setting, keeps word spaces constant and allows the right-hand edge to be ragged. Unjustified setting was not generally adopted in professional typesetting until well after World War II, and it is likely that the widespread use of the typewriter, where full justification was difficult to achieve, was one of the influences that made this style acceptable.

The style of the print edition of this book is for paragraphs to be unjustified, ranged left, without word division. The following paragraphs are set differently, to show the effect of (*a*) full justification without word division; (*b*) full justification with word division; (*c*) unjustified ranged-left setting without word division; (*d*) unjustified ranged-left setting with word division; (*e*) unjustified ranged-right setting.

(*a*) When paragraphs are set justified without word division, spaces between words can vary considerably from line to line. Allowing word division at the ends of lines will reduce this variation. In justified setting, minimum, optimum, and maximum words spaces are defined. In unjustified setting word spaces are constant, and can be defined by the designer. The length of lines can vary considerably if word division is not allowed. Unjustified setting that is ranged right is not suitable for continuous text.

(*b*) When paragraphs are set justified without word division, spaces between words can vary considerably from line to line. Allowing word division at the ends of lines will reduce this variation. In justified setting, minimum, optimum, and maximum words spaces are defined. In unjustified setting word spaces are constant, and can be defined by the designer. The length of lines can vary considerably if word division is not allowed. Unjustified setting that is ranged right is not suitable for continuous text.

(*c*) When paragraphs are set justified without word division, spaces between words can vary considerably from line to line. Allowing word division at the ends of lines will reduce this variation. In justified setting, minimum, optimum, and maximum words spaces are defined. In unjustified setting word spaces are constant, and can be defined by the designer. The length of lines can vary considerably if word division is not allowed. Unjustified setting that is ranged right is not suitable for continuous text.

(*d*) When paragraphs are set justified without word division, spaces between words can vary considerably from line to line. Allowing word division at the ends of lines will reduce this variation. In justified setting, minimum, optimum, and maximum words spaces are defined. In unjustified setting word spaces are constant, and can be defined by the designer. The length of lines can vary considerably if word division is not allowed. Unjustified setting that is ranged right is not suitable for continuous text.

(*e*) When paragraphs are set justified without word division, spaces between words can vary considerably from line to line. Allowing word division at the ends of lines will reduce this variation. In justified setting, minimum, optimum, and maximum words spaces are defined. In unjustified setting word spaces are constant, and can be defined by the designer. The length of lines can vary considerably if word division is not allowed. Unjustified setting that is ranged right is not suitable for continuous text.

Mode of symbolization	Method of configuration						
	Pure linear	*Linear interrupted*	*List*	*Linear branching*	*Matrix*	*Non-linear directed viewing*	*Non-linear most options open*
Verbal/numerical	lettering around the frieze of a building	conventional typeset prose	ordered or unordered list; poetry	family tree; decision algorithm	table	advert scattered with salient words	print-making with type; Dada typography
Pictorial and verbal/numerical	Bayeux Tapestry	page from a graphic novel in comic strip form	list of symbols with verbal explanations	family tree with portraits	table to identify e.g. birds' eggs by size or colour	exhibition catalogue; tabloid newspaper	pictorial map; Google Earth with labels
Pictorial	relief sculpture on Trajan's Column, Rome	sequence of wall paintings, e.g. fresco cycle around a chapel	list of symbols on motorway service station sign	pictorial explanations of processes and organization structures	pictorial sequences presented in parallel	naturalistic illustrations, especially those using perspective	aerial photograph; satellite map
Schematic	diagram of a single railway line; graph plot	musical score	[*rarely if ever used*]	schematic tree diagrams	bar charts	network diagrams, e.g. London Underground	cartographic map

12. **A schema of configurations of graphic language (after Twyman). The examples shown are not intended to be exhaustive.**

Chapter 3
Presenting language

Spoken language is resolutely linear. When we speak, we generate a continuous stream of sounds, which the listener decodes into words, and obtains meaning from those words. This linearity is why the order of words in most languages is critical to meaning, and why linguists are so concerned with the sequential (syntagmatic) relationship between words. We therefore recognize the significance of linear order when we listen, and when we come to write, strive to craft complete sentences whose meaning is clear from the order of their elements. To demonstrate this linearity, here is part of the BBC Shipping Forecast for inshore waters, as we listen to it on the radio:

> Viking. Southerly veering westerly or south-westerly 5 or 6, occasionally 7 later. Slight or moderate, occasionally rough later. Rain then showers. Moderate or good. North Utsire. Southerly veering westerly or south-westerly 4 or 5, increasing 6 at times. Slight or moderate. Rain then showers. Good, occasionally poor at first. South Utsire. Southerly veering westerly or south-westerly 4 or 5, increasing 6 at times. Slight or moderate. Rain then showers. Good, occasionally poor at first.

The words (they are not always sentences) fall into a regular, repeating sequence, and are part of the lexical set of weather forecasting terms. Their membership of that set imbues otherwise

ordinary words (*good, fair, slight*) with specific, calibrated meanings far more precise than when they are used in ordinary speech. Is it this oddly patterned use of ordinary words, mostly adverbs and adjectives, read in a deliberately neutral voice with slight pauses, that makes listening to the Shipping Forecast so mesmerizing and even calming for landlubbers? The inshore mariner isn't listening to be mesmerized, but to catch the name of the sea area they are sailing in, and then to extract the weather data that follows. The mariner mentally inserts the missing labels for the data they are hearing, knowing that the order is *wind (direction, speed), sea state, weather, visibility.* Those of us who are not in peril on the sea need to graphically transform the linear verbal sequence to extract the data. First let's try setting it out line for line, as a list (is this how the announcer's script is laid out?):

Viking.
Southerly veering westerly or south-westerly 5 or 6, occasionally
7 later.
Slight or moderate, occasionally rough later.
Rain then showers.
Moderate or good.
North Utsire.
Southerly veering westerly or south-westerly 4 or 5, increasing
6 at times.
Slight or moderate.
Rain then showers.
Good, occasionally poor at first.
South Utsire.
Southerly veering westerly or south-westerly 4 or 5, increasing
6 at times.
Slight or moderate.
Rain then showers.
Good, occasionally poor at first.

As we can see, this doesn't give enough salience to the all-important sea areas, and we are still relying on the sequence to

decode each piece of data. The common alignment of lines at the left causes ambiguity. We could format the list more heavily:

Viking

- Southerly veering westerly or south-westerly
 5 or 6, occasionally 7 later
- Slight or moderate, occasionally rough later
- Rain then showers
- Moderate or good

North Utsire

- Southerly veering westerly or south-westerly
 4 or 5, increasing 6 at times
- Slight or moderate
- Rain then showers
- Good, occasionally poor at first

This is better, but what we need is a presentation that will let us allow access to the sea area that we are interested in *and* that puts back in those (unheard) data labels. Here is the same Forecast presented as a table:

Sea area	Wind		Sea state	Weather	Visibility
	Direction	*Speed (knots)*			
Viking	Southerly veering westerly or south-westerly	5 or 6, occasionally 7 later	Slight or moderate, occasionally rough later	Rain then showers	Moderate or good
North Utsire	Southerly veering westerly or south-westerly	4 or 5, increasing 6 at times	Slight or moderate	Rain then showers	Good, occasionally poor at first
South Utsire	Southerly veering westerly or south-westerly	4 or 5, increasing 6 at times	Slight or moderate	Rain then showers	Good, occasionally poor at first

The table demonstrates two of the advantages of visual language over spoken language—simultaneity and accessibility of information. At one glance we can see the overall structure of the

Forecast. We can focus on the data that is specific to a single sea area by reading across a row, but (unlike the list) we can also easily compare specific conditions in different areas by reading down a column. If we were at sea, the table would enable us to decide which sea area we should sail towards to find better weather.

Of course, the Shipping Forecast is a highly specialized form of speech. It is bound by convention (sequence, lexical set, style of delivery) and is read by expert readers for expert listeners. When speaking normally we recognize that, above the level of a single sentence, we can rely less on syntax and so we insert specific structural or cohesive cues for the listener to pick up. For example, if we start a sentence with 'on the one hand', the listener will expect a point of view to be put, which will be balanced once we go on to say 'but on the other'. As listeners, we are constantly noting these cues to create an overall understanding of the speaker's intentions, trying always to hear, from the stream of words with which we are presented, the ideas behind them.

These structural cues in speech help designers visualize language. Poets have also sought to visualize ideas in this way: the Polish poet Stefan Themerson (1910–88) developed the technique he called 'internal vertical justification' to present the ideas in a poem, releasing them from the normal vertical sequence of lines to emphasize the units of meaning, which he rendered as if they were dictionary definitions—hence 'semantic poetry'. Here is his 'Semantic poetry translation of the Chinese poem: "Drinking under the moon" by Li Po':

Let	influence	by	feedback	the	object of which
us	ourselves		from		is
three			each		to stimulate
					the
					pleasure centre
					in
					our brain!

Configurations of graphic language

To help us think about the visual presentation of language we can look at a schema developed by Michael Twyman (Figure 12, p. 40). It shows how graphic language can be presented, by considering the method of configuration (how the example is arranged spatially and semantically) and the mode of symbolization (whether the example consists of words or images, or both). The categories in the schema allow us to understand how information can be presented in different ways to enable different reading strategies and outcomes.

Tywman's modes of symbolization are verbal, numerical, pictorial (any kind of representational image, however conventionalized), and schematic (any kind of pictorial chart, diagram, or map, etc.); these modes can be combined. We can return to the Shipping Forecast, using the schema to analyse its presentation.

The first presentation of the Shipping Forecast that we saw would be categorized as 'linear interrupted'. This is the most common configuration of prose: linear means that, within the unit of text being considered, we read on in the natural reading direction until we get to the end of the unit; interrupted recognizes that purely practical constraints (the length of the line, the width of the page or screen) require the linear flow to be interrupted, but that these should not be regarded as semantic—line ends do not equate to the boundaries between sense units. We read on, not paying attention to line or page breaks, or to the need to scroll down a screen. (It is difficult in the modern world to find examples of purely linear text that are more than a few words long: the inscription on a frieze around a building could be one.)

The second presentation of the Shipping Forecast matches the schema category 'list'; this configuration is not ideal for the Shipping Forecast, but it is an improvement on linear interrupted. In a list each line is ideally a discrete semantic unit. But notice

that the wind data for each sea area are too long to fit on a single line in the print edition of this book, and their turnover lines are ambiguous because they return to an alignment that otherwise indicates the start of a new semantic unit. This is why lists with long entries need unambiguous formatting, such as the bullets and hanging indent used in the third presentation of the Shipping Forecast. By cueing the start of items within a list we can confirm the boundaries of these semantic units, and we can also indicate the status of the items within a hierarchy.

The fourth presentation of the Shipping Forecast fits the category 'matrix', that is, language presented in a grid of cells, which can be read either by row or column. Finally, we have come to a configuration that is better suited to the semantic content of the Shipping Forecast. But notice that we have had to add words that were not present in the original spoken text. Such adjustments to content (and punctuation) are not unusual when moving from one configuration to another. Within a matrix, we may find that we describe the text content of a particular cell as linear interrupted, because it is too long to fit the practical width of the cell; but this does not detract from the overall semantic significance of the columns, rows, and cells. Configurations can be combined, or nested. Themerson's 'semantic poem' uses both matrix and list configurations, each with a different hierarchical status. Overall it is a matrix, but with only one row; within the cells there are list-like configurations where each line break is intentional and has a semantic value, albeit one that, because of the reading order, is secondary to the primary division into horizontal cells.

A further configuration is the linear branching model. Text presented in this way looks even more like a diagram than the other configurations. This is particularly good at showing hierarchical, parent–child relationships, and so it is used for family trees and decision algorithms (Figure 13 on p. 59 is an example of the latter). Formatting the Shipping Forecast in a linear branching presentation produces a result that is more space-consuming than

a list and less amenable to easy look-up than a matrix, but it does clearly show the hierarchical relationships.

In order to save space, text that is conceived as a branching tree is usually presented collapsed into what looks like a list or a sequence of paragraphs. Presenting a dictionary entry as a branching tree lets us identify the individual components which make it up, but again the space-consuming nature of the configuration relative to a more conventional presentation is obvious (compare with Figure 9 on p. 27).

Branching tree structures that are presented as lists can also be indicated by numbering paragraphs with decimal notation: 1, 1.1, 1.2, 1.2.1, 1.2.2, 1.3, 1.4, 2, 2.1, 2.1.1, 2.1.2, 2.2, and so on. Acts of Parliament and other legal documents use this presentation.

Directed and open reading

One value of Twyman's schema is that it helps us understand how configurations can direct our reading—or leave it open. Reading from left to right and top to bottom needs to be reinforced for continuous text, but this predisposition needs to be overcome for documents where this normal reading sequence is inappropriate. Recognizing this, the schema differentiates between 'directed reading' and 'open'. Two different kinds of page can illustrate these configurations, and show that the choice between them is purposeful and results in different user interactions. An exhibition catalogue where each work is illustrated, identified, and described separately allows a reader to work sequentially through the exhibits or seek out an image that is of particular interest and read the text that accompanies it; either way the reader is firmly directed by the regularity of the grid-like layout. A tabloid newspaper page offers the reader a mosaic of images, headlines, text, and advertisements, all pretty much unrelated; while there is a scale of prominence, it really doesn't matter which item the reader alights on first. The visual differences between the two layouts are to do with salience: the catalogue page can be relatively quiet, as it only has to nudge the reader into their reading choice. The tabloid page must use sledgehammer differences in size and boldness, and rules and borders, because in this case proximity and alignment are no real indicator of semantic relationships.

The same distinction applies to pictorial or schematic content. A map consisting of an aerial photograph, or of conventional representational cartography does not provoke a particular reading direction—towns and cities are dotted around the map with the connections between them indicated, but not prioritized over other geographic elements. We might be able to see railways or roads, but the map is neutral about them, so it can be categorized as 'non-linear, open'—the reader can trace any route as they please, by multiple means. The London Underground diagram, on the other hand, can be categorized as 'non-linear,

directed'. The Underground lines are privileged and each is visually differentiated by colour, and there is no other transport or geographic information (apart from a schematic Thames); the Underground lines are the only routes on offer that we can use to find our destination.

Hierarchy

Not all our spoken utterances are of equal value. Similarly, the flow of text in a document will very rarely consist of elements of exactly equal value, although a printed telephone directory of private subscribers might come close. We've already seen that in speech we use what linguists call cataphoric (looking ahead) statements to cue our listeners to the status of what we are about to say. In written language, statements such as 'I'll now turn to the weather' can be translated into a heading, the words following 'I'll give you three examples' into an ordered list, and the words following 'I heard Jane say' into a quotation.

The particular sequence and combination of these elements defines the structure of a text. In visualizing this structure, typographers typically use salience (visual prominence achieved by spatial or contrast differences, or a combination of both) in some graded way to identify analogically sequential or nested elements in the text flow. The salience value we give to any element may be determined from two standpoints (although they will often overlap): one is a reading of the writer's intention, the other is an assumption of the reader's requirements. The typographer's role is to mediate between these poles, sometimes by reminding the writer or editor of the reader's needs. There may also be external determinants of how salience is implemented, such as technical limitations (the typeface chosen may not have a bold variant; colour may not be available) or genre or house style conventions (for example, a publisher may require that no more than two heading levels in text can be used, or that the publication has to match an existing design template).

In the 1920s, the gestalt psychologists set out principles of perception that explained why many conventional typographic presentations of hierarchy work, and validated much tacit craft knowledge in design. Put simply, their essential thesis was that we perceive the whole as different from the sum of its parts: we perceive relationships *between* elements as well as the features of individual elements. In thinking about hierarchy, the most relevant gestalt principles are the similarity principle and the proximity principle. The first tells us simply that we group things that resemble each other, and share similar characteristics and properties. If all headings are set in bold type, and all body text in roman, this will reinforce the difference between them, so that we are less likely to confuse a single line in roman type for a heading, instead recognizing it as a single-line paragraph. The proximity principle tells us that while we see individual elements, we perceptually group objects on the basis of their nearness to one another. Elements that are close together are perceptually grouped together, all other things being equal. These two principles can be used separately or, more powerfully, together. Spatial proximity is one of the most powerful organizing principles, and therefore one of the most useful tools of the typographic designer. If headings are closer to the text that follows them than they are to the text above, then their connection to the following text will be reinforced. (These principles apply equally to other aspects of typography, notably layout: see Chapter 4.)

We can demonstrate these principles by using Michael Twyman's symbolic representations of common arrangements of headings and text. The advantage of using symbols instead of words is that we can concentrate on the visual presentation without distraction. In the following examples, an x indicates the normal, underlying style of body text, and an o any variant (italic, bold, capitals). Where a second kind of variant is used, it is indicated by an i. This notation deliberately reduces the contrast value of the headings relative to body text, which has the effect of reducing our reliance on the similarity principle, and we begin to see that

spatial relationships are perhaps more important than contrast
relationships.

```
xxxxx                  xxxxx                  xx  xxxxx
xxxxxxxxxxxxxx         xxxxxxxxxxxxxxx             xxxxxxxxxxxxxx
xxxxxxxxxxxxxxx        xxxxxxxxxxxxxxxx            xxxxxxxxxxxxxx
xxxxxxxxxxxxx          xxxxxxxxxxxxxx              xxxxxxxxxxxxx
xxxxxx
xxxxxxxxxxxxxxx        xxxxxx                  xx  xxxxxx
xxxxxxxxxxxxx          xxxxxxxxxxxxxxx             xxxxxxxxxxxxxx
xxxxxxxxxxxxxxx        xxxxxxxxxxxxx               xxxxxxxxxxxxx
                      xxxxxxxxxxxxxxx             xxxxxxxxxxxxxx
```

(*a*) (*b*) (*c*)

In these three examples there is no variation of style at all between
the body text (shown as long lines of xs) and the headings (short
lines of xs). In diagram (*a*), simply setting a heading on a new line
(line 1) is not enough to distinguish it—it could be confused with
the short last line of a paragraph (line 5). Adding vertical space
above the heading, as in (*b*), makes the distinction clear, despite
the lack of contrast; and it is further reinforced by the hanging
numbering system in (*c*).

```
xxxxxxxxxxxxxxxxxxxx    xxxxxxxxxxxxxxxxxxxx    xxxxxxxxxxxxxxxxxxxx
xxxxxxxxxxxxxxxxx       xxxxxxxxxxxxxxxxx       xxxxxxxxxxxxxxxxx

00000                  00000                  00000
xxxxxxxxxxxxxxxxxxxx    xxxxxxxxxxxxxxxxxxxx
xxxxxxxxxxxxxxxxx       xxxxxxxxxxxxxxxxx       xxxxxxxxxxxxxxxxxxxx
  xxxxxxxxxxxxxxxxxx                             xxxxxxxxxxxxxxxxx
xxxxxxxxxxxxxxxxxxxx    xxxxxxxxxxxxxxxxxxxx      xxxxxxxxxxxxxxxxxx
xxxxxxxxxxxxxxxxxxxx    xxxxxxxxxxxxxxxxxxxx    xxxxxxxxxxxxxxxxxxxx
```

(*d*) (*e*) (*f*)

Using a variant style of type for headings allows more flexibility.
The proximity principle is at work in (*d*): there is more space
above the heading than below, so the heading is clearly related to
the following paragraphs. But (*e*) is ambiguous because the space
between the last two paragraphs is equal to the space above the
heading. Does the heading include both the paragraphs beneath
it? The solution of using indented paragraphs with no additional
vertical space in (*f*) makes things clearer (the two paragraphs are
both covered by the heading). But the spaces around the heading
are not ideal, as it sits exactly midway between two slabs of text;

we are relying on the similarity principle, i.e. its contrast to the body text, to identify it as a heading. Diagram (*g*) shows both the similarity and proximity principles at work, with the space above the heading clearly greater than the space below, or between paragraphs.

```
xxxxxxxxxxxxxxxxxxxx
xxxxxxxxxxxxxxxxxx

ooooo

xxxxxxxxxxxxxxxxxxxx
xxxxxxxxxxxxxxxxx

xxxxxxxxxxxxxxxxxxxx
xxxxxxxxxxxxxxxxxxxx
xxxxxxxxxxxxxxxxxxxx
```

(*g*)

There will be many instances where there are constraints on the available vertical space, and option (*g*) will be impractical. Diagram (*h*) shows the use of contrast *and* horizontal indenting and outdenting to produce a more compact result than the ideal vertical spacing, (*i*), when four levels of heading are required. This shows that we can use horizontal alignment to trigger the similarity principle when using vertical spacing is difficult.

Typography

```
xxxxxxxxxxxxxxxxxxxx        xxxxxxxxxxxxxxxxxxxx
xxxxxxxxxxxxxxxx            xxxxxxxxxxxxxxxx
ooooo
  xxxxxxxxxxxxxxxxxxxx      ooooo
  xxxxxxxxxxxxxxx
  ooooo                     xxxxxxxxxxxxxxxxxxxx
    xxxxxxxxxxxxxxxxxxxx     xxxxxxxxxxxxxxxx
    xxxxxxxxxxxxxxxxxxxx
    xxxxxxxxxxxxxxxxx        ooooo
      iiiii                 xxxxxxxxxxxxxxxxxxxx
    xxxxxxxxxxxxxxxxxxxx     xxxxxxxxxxxxxxxxxxxx
    xxxxxxxxxxxxxxxx         xxxxxxxxxxxxxxxxx
      iiiiixxxxxxxxxxxxx       iiiii
    xxxxxxxxxxxxxxxxxxxx     xxxxxxxxxxxxxxxxxxxx
                            xxxxxxxxxxxxxxxx
                              iiiiixxxxxxxxxxxxx
                            xxxxxxxxxxxxxxxxxxxx
```

(*h*) (*i*)

Together, these concepts of how the organization of thought in language can be represented by graphic configuration, and how hierarchical relationships within a text can be visually represented,

are at the heart of typographic design. Their common feature is that both concepts assist us in planning design solutions that are rational responses to the text because they invoke the immediate, unambiguous understanding of the reader. Indeed, the choices offered by the first concept, choosing between modes of symbolization (should I use just words? should I add images? should I use symbols?) and choosing between methods of configuration (is a table or a list better here?) are often made by writers and editors who might not consider themselves visual designers. In fact, all parties have a stake in the clarity of the visual language that they produce for the reader. This emphasizes the need for collaborative workflows that integrate such decisions with those which are more often seen as the typographic designer's domain, such as deciding on the spatial and contrast values of hierarchical elements. In Chapter 4 we will see how such collaboration can work in creating effective documents; in Chapter 5 how it can create memorable information visualization.

Describing text and documents systematically

So far we have looked at the typography of text from the outside, as it were, observing how visual configurations can be applied and what they look like. But we will have a clearer appreciation of the typographer's task if we look below the surface to the way that a text stream is stored and manipulated digitally, so that we can better describe that text's structure. The surface way of describing a document is to describe the visual attributes of the type used to render the text. We can call this a procedural or prescriptive specification. It tells us how to go about formatting the text, which fonts we will need, how the page grid should be set up, what rules apply to the details of setting the type. This would result in saying that the body text of the print edition of this book is set in 8.5/12 pt Miller Text, unjustified across 20½ picas, with 36 lines to a page, and a line space between paragraphs. And that the chapters begin with words in various weights and sizes of OUP Argo, and so on.

All this is perfectly true, and it is absolutely necessary to describe this book accurately if we want to instruct someone else to recreate a *Very Short Introduction*: it tells us about decisions that have been made by the designer. Before the computerization of text, procedural specification was the only way to define how a document could be typeset. But describing text only in terms of its visual attributes is putting the cart before the horse. The visual attributes only exist because they present the structure of the document to the reader. A procedural specification only indirectly tells us about the structure of the text, and if we wanted to transform the book to another format or to another medium, then simply describing the existing typefaces and sizes would not be much help. After all, a document may have gone through many writing and editing stages that determined its structure before the final surface appearance was given to it. To make such a transformation, we need a way of describing the document itself, not the particular instantiation of it that we happen to be looking at. And it may not be practical to map everything in one particular typeface or size when undertaking such a transformation. Words in italic, for example, can conventionally represent a number of possible categories of text:

Date and criticism

The play *Julius Caesar* was written *c*.1599. The line '*Et tu Brute?*' ('You too, Brutus?') provides the title of Greg Woolf's book *Et Tu, Brute? A Short History of Political Murder*.

In this example they represent, in order: a heading, a play title, a Latin abbreviation, words in a foreign language, and a book title. 'Italic' therefore simply describes the appearance of these words, not their status in the text. If we adopt structural (also called semantic) markup to describe the document, each of these elements can be clearly distinguished. We could search for these specific markup elements, and we could choose how to map them to typographic styles if we transform the book to another format or medium.

<h3>Date and criticism.</h3> <p>The play <work>Julius Caesar</work> was written <it>c</it>.1599. The line '<cited>Et tu Brute?</cited>' ('You too, Brutus?') provides the title of Greg Woolf's book <work>Et Tu, Brute? A Short History of Political Murder</work>.</p>

The kind of markup used here may look familiar, because it is similar to HTML markup used to format web pages. HTML (hypertext markup language) is actually a hybrid of structural and procedural markup, because it allows visual presentation (fonts, colours, sizes) to be declared alongside the structure, that is it both defines the structure and provides instructions on how it should be rendered. A purely structural markup system such as XML (extensible markup language) only describes the structure and does not include specific rendering instructions, which are handled separately by XSL (extensible style sheet language). This separation of structure and rendering allows documents to be repurposed between media, and to be stored and worked on collaboratively using generic, cross-platform editing tools. It also allows text to be imported into dedicated rendering systems, including typographic design applications such as InDesign. On import, the incoming structural tags are mapped to style sheets created in the application, so that they are rendered appropriately for that particular instantiation of the text.

The idea of markup that was declarative, so that it simply describes the document's structure rather than how it should be rendered, was developed by Charles Goldfarb and others at IBM in the 1960s to enable the sharing of text-based data. One of the first uses in book publishing of IBM's standard generalized markup language (SGML), from which HTML and XML descend, was the second edition of the *Oxford English Dictionary* in 1985.

How do we define the markup elements for a document? An intuitive way to understand a book's structure is to start with the contents page. This will list the front matter or prelims (the

preface, list of illustrations, and other items that come before the main text), the parts, chapter numbers and titles, and end matter (appendices, indexes). But contents pages are written to help the average reader find their way around the book and (except in very technical works) do not exhaustively list every section and subsection within a chapter. We may find out that there are equations, tables, or music examples if these are listed separately but it is unlikely they are listed in place on the main contents, so the whole text needs to be analysed.

To be useful, markup must be comprehensive and thoroughgoing, When we analyse a document at the level required to apply a comprehensive markup, the result is a sequence of nested, repeating structures such as this:

```
<anthology>
  <poem>
    <heading>THE SICK ROSE</heading>
    <stanza>
      <line>O Rose thou art sick.</line>
      <line>The invisible worm,</line>
      <line>That flies in the night</line>
      <line>In the howling storm:</line>
    </stanza>
    <stanza>
      <line>Has found out thy bed</line>
      <line>Of crimson joy:</line>
      <line>And his dark secret love</line>
      <line>Does thy life destroy.</line>
    </stanza>
  </poem>
  <!-- more poems go here -->
</anthology>
```

which results in this rendering if appropriate styles are applied:

THE SICK ROSE

O Rose thou art sick.
The invisible worm,
That flies in the night
In the howling storm:

Has found out thy bed
Of crimson joy:
And his dark secret love
Does thy life destroy.

Markup differentiates elements that were ambiguously described as italic in procedural markup. When we come to typeset a document for print in an application such as InDesign, we can apply consistent typography to the document elements by importing an XML file and mapping the incoming tags to paragraph and character styles. In defining these mappings, we can differentiate as much or as little as we please: we can choose to continue mapping headings, works, Latin abbreviations, and foreign words to italic, if that is appropriate, but the underlying text stream will maintain the distinctions.

Using an XML file as a source for typesetting or web page creation is the most rigorous workflow option, but the principle of defining structure and significance within the document, rather than appearance, holds good for the organization of typography however the text is created and designed. Although at first glance it may seem procedural rather than structural, rigorously using paragraph and character styles in Word (for document creation and editing) and InDesign (for typesetting and page layout) allows writers, editors, and designers to define the structure of a document for print production almost as efficiently.

Text and pages

Structural markup treats a text as a whole, containing sub-elements but ultimately indivisible, and records it as a continuous text stream that avoids explicit statements about its presentation in the physical world. So we have to write a set of instructions to render the text for human reading, that is we have to design it for a specific presentation in a specific medium. Understanding how a text is semantically structured allows us to do this task more effectively. Any presentation of a text (except for the very shortest) in print or on any kind of screen involves dividing that text up into chunks—pages or screens which are determined by the physical attributes of the communication medium or device. The aim of any typographic design is to do this while respecting the configurations and hierarchical structures in the text.

The first task is to divide the text into lines and justify it. This may sound simple: move from left to right, fitting in as many complete words as will fill the line, then stop, go down a line, and start again at the left. But if you do this, especially without dividing words, the resulting page doesn't look very good at all. In fully justified setting, a line with small word spaces may be followed by a line with large word space, which looks disturbing. In ragged setting, a short word at the end of a long line may look unsupported when the following line is shorter. A very short word may look lost on its own on the last line of a paragraph. These problems are solved by an algorithm co-authored by Donald Knuth, who devised it in the 1980s as part of the TeX system for mathematical typesetting (it is now used in other typesetting applications; Figure 13). This calculates the optimal line ends across a whole paragraph, so that word spaces or line lengths are as even as possible. (A version of the Knuth–Plass algorithm is used to compose this text in the print edition, but without full justification or word division.) The model it adopts to achieve this is one that can be applied to all decisions about how to break a text into pages (or screens): it involves the concepts of boxes, glue, and penalties.

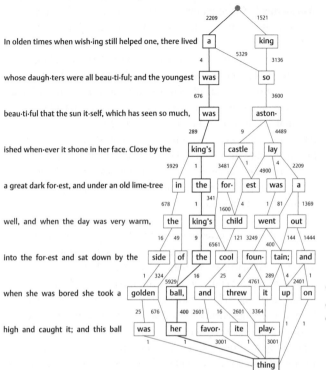

In olden times when wish·ing still helped one, there lived **a** **king**

whose daugh·ters were all beau·ti·ful; and the youngest **was** **so**

beau·ti·ful that the sun it·self, which has seen so much, **was** **aston·**

ished when·ever it shone in her face. Close by the **king's** **castle** **lay**

a great dark for·est, and under an old lime-tree **in** **the** **for·** **est** **was** **a**

well, and when the day was very warm, **the** **king's** **child** **went** **out**

into the for·est and sat down by the **side** **of** **the** **cool** **foun·** **tain;** **and**

when she was bored she took a **golden** **ball,** **and** **threw** **it** **up** **on**

high and caught it; and this ball **was** **her** **favor·** **ite** **play·**

thing

Presenting language

In olden times when wishing still helped one, there lived a
king whose daughters were all beautiful; and the youngest was
so beautiful that the sun itself, which has seen so much, was
astonished whenever it shone in her face. Close by the king's
castle lay a great dark forest, and under an old lime-tree in the
forest was a well, and when the day was very warm, the king's
child went out into the forest and sat down by the side of the
cool fountain; and when she was bored she took a golden ball,
and threw it up on high and caught it; and this ball was her
favorite plaything.

13. (*top*) **A visualization of the Knuth–Plass algorithm for selecting
optimal line endings in typesetting. The heavier boxes contain the
optimal choices, where the total number of penalties, 3606, is the least.**
(*bottom*) **The resulting setting.**

We can think of a paragraph as a string of boxes (words) with glue (spaces) between them. The glue is stretchable and shrinkable by amounts that we can determine. Certain situations (such as a very short word on its own at the end of the last line or large differences between spaces from line to line in justified setting) incur penalties. We can allow words to divide if we wish, applying logical or dictionary-based rules of word division, and different divisions can also incur different penalties. Because we can set different penalty values for different situations, we can rank them in acceptability, making the algorithm choose the solution with the least number of penalties overall. This implies that a suboptimal solution may be chosen for a single line if it improves the overall solution for the paragraph.

Knuth's algorithm solves the problem of dynamic typesetting: changes in one parameter of a page or screen presentation, say the size or the typeface, or a change in the text, will redefine the line and page breaks. While the algorithm was developed for English-language setting and for mathematical equations, the concepts behind it are of particular importance for non-Latin scripts such as Arabic. Based closely on handwriting conventions, Arabic typesetting requires the shapes of individual letters to change or to join with others in different ways depending on their context or position in a word. There are complex rules for the positioning of diacritics. Typesetting routines for Arabic have to abide by these rules, so that the sequence of characters that is keyed and recorded as the underlying text stream is transformed automatically by the typesetting application into the particular forms required by the words as they are composed.

The box–glue–penalty model can be applied more widely. TeX uses it to optimize the division of a document into pages. It can prevent a heading becoming detached from its text at a page break and ensure that a picture and its caption are kept together on a page. In this way, TeX and similar typesetting systems simulate the decision algorithms that were used, albeit tacitly, by compositors

Typography

who set metal type and made up pages by hand. It has always been good practice to ensure that decisions made at the ends of lines and at the ends of pages do not confuse readers, whether by dividing a word inappropriately or by separating two pieces of text, or text and an illustration, that should be seen together. In a play, for example, a character's name must not be separated from their dialogue, a stanza in poetry should be divided to respect its rhyme scheme, and it looks awkward if the last line of a paragraph sits alone at the top of a page. Much of the traditional work of a typographer, when text composition and make-up was handled by printers, was to write careful specifications that gave guidance on such details, working with compositors' craft knowledge and the typographic standards of the printing house. These standards, enforced by printing houses and codified into 'house style' guidelines, depended on the opportunities for quality control that came from a trained workforce and a workflow that offered multiple points of intervention, inspection, and correction. Now that printers rarely undertake text composition, and typesetting is sometimes done by writers, sometimes by designers, and sometimes by 'content publishing service providers', the ability to rely on typographic standards being maintained by anyone downstream of the designer without precise and detailed specifications has dwindled. The challenge now for typographers is to supply specifications as templates and style sheets rather than as lists of instructions. This requires a thorough knowledge of the technicalities of typesetting applications. The implementation of detail in text typography is still one of the most painstaking but rewarding aspects of the job.

Prescription and house style

We have discussed language as if it is somehow neutral, despite its reconfigurability. But at another level our use of language indicates to others something of our identity and perhaps tells them (and us) something of who we want to be. Language functions efficiently within a language community whose members share a common

understanding of the world and the way it can be described in words. While some writing is intended to stay within a tightly defined group (a scientific journal article, for example, is not expected to be read outside its specific discipline), some (such as advice to the public on a government website) is intended to have the widest possible audience, which may include every citizen of a country. Organizations—commercial, governmental, and social—need to use language in a way that indicates their identity so that they can construct relationships with their audiences. Choices about vocabulary and grammar (lexical and syntactical questions) need to be answered before a writer can communicate information effectively.

Linguists such as David Crystal and Judy Delin have written about this approach to language. Part of the role of typography is to support the aim of writing in relation to an audience, either ensuring that it is focused and taken seriously by a small, specific readership, or accessible and understandable by the widest audience. The aspect of typography that serves this need is sometimes called house style, in reference to the typographic house styles of printers. It is an area on which books on typography traditionally placed a great deal of emphasis (see Appendix 2). House style operates on an editorial as well as a typographic level. It prescribes certain spellings, capitalizations, and usages, and also describes preferred configurations, modes of symbolization, and visual implementations of hierarchy. In this way it demonstrates the interdependence of the language that we use (at the level of words and sentences) and the visual form that we give it in a publication with any claim to permanence.

In the past these standards were embedded in in-house guides for copy editors, typesetters, and proofreaders. Now publications such as *New Hart's Rules* (Oxford University Press), *The Chicago Manual of Style*, and *The Guardian*'s style guide are written to be useful to writers as well, and some are available online. The style guides used internally by newspapers and commercial

organizations, with specific audiences in mind, tend to emphasize which words should be used in certain contexts; publishers' public style guides are (beyond the norms of grammar) less prescriptive about how an author should write, and more prescriptive about typographic presentation. The following paragraphs are set first in Oxford's style and then in *The Guardian*'s:

> The Foreign Secretary—who had returned from a performance of *Macbeth* at the Edinburgh Festival—was interviewed at 4.15 p.m. by the editor of *The Guardian*. 'We realized it was . . . an awkward, fretful, and tricky situation,' the editor reported later.

> The foreign secretary – who had returned from a performance of Macbeth at the Edinburgh festival – was interviewed at 4.15pm by the editor of the Guardian. "We realised it was … an awkward, fretful and tricky situation," the editor reported later.

The differences between these styles reflect the differences between their respective genres: an academic text will benefit from as little ambiguity as possible, and it does not face the same pressures of compression and economy as a newspaper. So Oxford can afford to be more pedantic in the way it capitalizes specific job titles, and gives a little more space to the presentation of times of day and ellipses. A mark of Oxford style is the serial or Oxford comma ('awkward, fretful, and tricky'). Oxford also maintains the older tradition of using a long dash (em dash). *The Guardian* accepts more compressed forms and does not use italics for the titles of plays, books, or newspapers. Full points in abbreviations do not look as bad on a book page as they do in the narrow columns of a newspaper, where they produce a spotty effect. These differences (choices of capitalization and spelling, the style of dashes, dates, titles of publications, quotation marks, ellipses, serial commas) may be small in themselves, but they accumulate over a publication. Decisions on all of these points need to be established and implemented consistently if a publication, or series of publications, is to aspire to authoritative presentation.

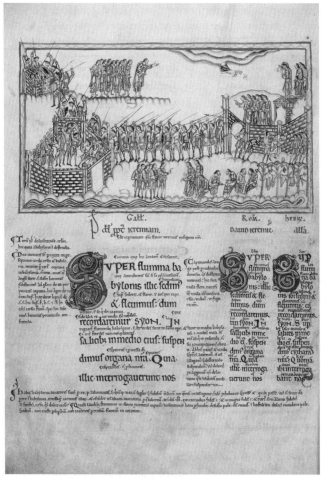

14. Biblical text with interlinear and marginal glosses, and parallel translations, twelfth century. Psalm 136, 'By the waters of Babylon', from the Canterbury Eadwine Psalter.

Chapter 4
Genre and layout

Layout is the arrangement of material on a page or screen that articulates the text we are reading. Layout is a recognition that we read different parts of a document differently. The earliest forms of the book, the scroll and the codex (the physical book as we know it, with pages hinged at the spine), supported a particular kind of reading, where memorizing the text in order to recall it verbatim was paramount. This allowed a linear visual presentation, with little if any spacing between words and paragraphs, that was close to the continuous linear quality of speech. This was appropriate when the clergy, the main producers and users of books, read a small number of books at a slow pace. The historian and librarian Christopher de Hamel argues in the *Oxford Companion to the Book* that major changes in the design of manuscripts occurred in the twelfth century, when the increasing demand for manuscripts led to the rise of professional scribes who replaced the work of individual monks:

> The changes were also due to an increase in the lay readership of books, including literate administrators and lawyers. Unlike monks, these were often people in a hurry. A MS of about 1200, usually in two columns, bristling with many carefully graded coloured initials, its margins packed with forms of apparatus for rapid reference, is very different in appearance from a typical book of 150 years earlier, commonly written as a single column of dense text, elegant but

austere, with few initials and scarcely any division between words and almost none between paragraphs.

The text of a manuscript would no longer be just the original work, but would include paratextual (helping) features such as interlinear or marginal glosses, which were important for Irish and English monks for whom Latin (the language of religious texts) was not their first language. With the development of new kinds of book—encyclopedias, anthologies, and concordances—comparisons and references between texts became increasingly important, and required solutions to help the reader navigate their pages. To make references to the Bible more precise, Archbishop Stephen Langton (1150–1228) developed the division of its books into the chapters that we still know today. The use of different sizes of different scripts, different coloured initials, and different columnar arrangements was therefore not simply a matter of decoration, but essential to the articulation of what were becoming increasingly complex documents (Figure 14, p. 64). We can see a typographic sensibility in these arrangements of text on the page, despite the hand-production method: glosses are often written smaller so that two lines exactly match up with a single line of the main text, establishing a modular relationship that enabled pages to be planned exactly into rectangular units.

The early printed book could not compete with the manuscript in the use of colour or illustration. Fresh from the press, and without the addition of hand rubrication by a scribe, Gutenberg's 42-line Bible of 1453–5 was a plain, black-and-white affair, set in a single size of type with no printed headlines or page numbers. But early printers realized the need to develop new paratextual devices to suit the mechanical book. Robert Estienne took Langton's Bible divisions further by subdividing chapters into verses in 1551; this and the Bibles he had printed previously were remarkable pieces of scholarly publishing. They provided strong visual guides to help readers find their way around the text, such as multiple sizes of type and printed (rather than hand-rubricated)

drop initials, numbering, and running headlines. In another response to the mechanically mass-produced book, the title page made its appearance. It was unknown in manuscripts, but by 1510 title pages were the norm and carried the name and often the device of the printer/publisher—indicating something of the commercial and collaborative nature of printing.

Typographic genres

Printed books continued and developed the tendency already seen in manuscripts for different kinds of books to become associated with particular formats or design paradigms. And as printing began to encourage new kinds of document beyond the religious or legal book, so these formats and paradigms began to coalesce into long-lived typographic genres. The portable, small-format editions for scholars, such as those produced by Aldus Manutius, Christopher Plantin (d.1589), and the Elzevirs in the seventeenth century were examples where the size and shape of a book indicated its purpose; today we recognize the mass-market paperback by the same characteristics. In Bible printing, the two-column pages of Gutenberg and Estienne became the norm; to the present day, multicolumn setting has been universal in printed dictionaries and encyclopedias. The concept of typographic genres can be applied widely. Readers need to be aware of both the physical organization of the book and the logical structure of the work it contains, and clearly defined genres aid this awareness. As readers, we are experts at recognizing genres, and respond to publications instinctively because we have learnt what particular combinations of graphic presentation and content signify.

In linguistics and literary criticism, a genre refers to a collection of artefacts or behaviours that share structural features and fulfil common communicative functions: a fairy tale, a business memo, a sales presentation. What then defines a typographic genre? The information designer Robert Waller sees a genre as the interplay

between the particular contents and intentions of a writer's text (the 'topic structure'), the constraints of the physical format and the way this affects what can be expressed (the 'artefact structure'), and the opportunities the presentation gives to readers so that they can access information (the 'access structure').

Topic structures vary considerably, and may embrace a number of different ways of writing and expect different kinds of reading. A college textbook will have an overall topic structure that treats its subject chronologically or thematically; a dictionary will be ordered alphabetically. The textbook will be constructed in sections that introduce an idea and say why it is important, expand the idea with evidence, give examples, and finally test the reader on their understanding and provide further reading. This may involve the use of continuous prose, lists, tables, and the use of verbal, pictorial, and symbolic language. Each section will fit this pattern: overall, these sections will be presented as a logical system of learning. Within a single artefact, offering the reader access to this variety of material requires different typographic configurations for each kind of writing and reading task, but these will fall into a common repeating pattern that ultimately exemplifies the genre 'textbook'. The dictionary will comprise many hundreds of entries, identical in their components but different in length and complexity, so again the whole will be a dynamic repeating pattern of typographic elements.

Waller's approach to defining genre has the advantage of placing the reader clearly in the frame as a participant in the act of reading and not a passive recipient of information (readers recognize and navigate text structure and select what they wish to read by using visual cues). It also emphasizes that all kinds of documents have a determining part in the reading process (for example, by making a particular way of navigating or reading easier or more difficult, or making a text look more or less authoritative or accessible). Documents are not neutral channels through which information flows frictionlessly between writer and reader.

Genres are not simply conventions; they work for writers, producers, and readers. Reader interactivity with a document is a critical determinant of genre, and is implicit in its access structure. Books of all kinds have allowed readers to add marginalia to support their reading, understanding, or responses to the text, but anything which is purposely designed for the reader to write on and then submit is a form, whether on paper or online. Academic books have footnotes, allowing the reader to verify sources and do follow-up reading: popular non-fiction does not. Slow, extended reading indicates a book-like object (indeed, the prose-heavy magazines of previous centuries were popularly called books); the division between a magazine and a newspaper depends as much on whether it supports extended reading of longer articles or presents a mosaic of shorter stories, and the degree to which these are immediately topical, as much as on page size and the presence or absence of a bound spine.

While we can describe certain clear-cut genres, there are always documents which are hard to pin down. This little book, for example, poses questions about which genre it falls into: it is from an ancient university press, so it declares that it has some authority; but it is also small, short, and cheap. It is written by an academic and a practitioner; but it addresses the reader as 'you' and its typography is relatively informal, with unjustified columns and spaces between paragraphs, suggesting that ideas are presented in easily digested chunks. Finally, while it is on a highly visual topic, it has only a few illustrations in black and white. In all these areas, we seem to be assigning a rhetorical value to quite concrete presentational features. And parodies and satires, from *Tristram Shandy* to *Private Eye*, rely on genres, taking delight in adopting the verbal and visual dress and the rhetorical ambitions of the objects of their amusement.

Typographic genres of course change over time. What we recognize as a print newspaper today—with full colour throughout and high-definition images—would not have been technically

achievable fifty years ago. While the cultural divide between tabloid, mid-market, and broadsheet newspapers still exists in the UK and USA, the actual page dimensions of newspapers with these characteristics have changed, and so have the typefaces they are set in. But when we consider the artefact structure of newspapers in general, we see that reader expectations of the style and content of their preferred newspapers and the terms used to categorize them have remained. Genres borrow from each other: serious newspapers today have imported characteristics (short paragraphs, large headlines, dominant photographs and illustrations, fact boxes) from both tabloids and magazines, but still manage to integrate these features into their page layouts without losing their overall market distinctiveness.

This last point implies that details of layout and typography have a considerable effect on the way the whole of a publication is perceived. Is it possible to drill down to the features which determine a reader's visual reception of a text? Can we say that certain features have some rhetorical value, that they imply a certain meaning or intent? Research into readers' responses to different typographic and layout conventions undertaken by Jeanne-Louise Moys in 2014 has drawn out some of the rhetorical associations readers make when confronted with unfamiliar documents. This helps us understand how genres provide readers with shared meaning, and allow them to participate in discovering information. In 1990 Charles Kostelnick analysed the rhetorical functions of design (he calls them 'structural' when they indicate content organization and 'stylistic' when they indicate tone or usability):

> Since seeing precedes reading, the reader's first glance influences the information processing that follows. The balanced arrangement of visual elements on the page, the contrast among those elements, the efficient use of space—together these create a unified visual display that predisposes the reader to respond [strategically] to the information in the document.

So what do readers read into specific typographic configurations? Interestingly, when Moys's subjects were presented with linguistically meaningless text in carefully designed alternative layouts, they quickly made quite specific assumptions about the likely ease of reading, degree of factual content in, and potential usefulness of those documents even when they could not actually read the text. They responded to the presence of light rules and boxed elements in a layout as indications of seriousness, but when rules and boxes were made heavier, angled, coloured, or irregularly shaped, they were associated with sensationalism and other negative traits. These results seem to confirm that readers respond to both the structural and stylistic rhetorical functions of design as soon as they set eyes on a document. Some of the implications of this for different kinds of design (entertaining, informative, and persuasive) are discussed in Chapter 6.

Analysing layout

In 1968, Gui Bonsiepe attempted to quantify mathematically the quality of page layouts that consisted of a complex number of elements. He proposed a formula that counted the number of different shapes and sizes of elements on a page and their alignments, regarding the design with the smallest number of these as the best. Not surprisingly, this was viewed as mechanistic and reductive by other practitioners, as if the test of a good layout was its adherence to a grid. More recently, layout has been rigorously analysed by John Bateman and others, whose research considers the way that layouts combining text and pictures relate to concepts of multimodality. The idea of multimodality is important, as it recognizes that in print a typographic layout embodies words and pictures, and on a digital device may involve sound and moving images as well. Bateman's work looks at the way layout organization matches or mismatches the rhetorical organization of the text and images on a page. For example, in an instruction manual, a sequence of images should be organized to match the sequence of verbal instructions, and the relationship

between elements should be clear, so that the reader can move from instruction to image and back again in the correct order. If the layout forces images into false relationships with the text (because it is unclear which instruction each image refers to, or because the text is divided into a different number of instructions than are illustrated) then the layout is not supporting the aims of the text. This kind of mismatch is also apparent on many web pages, where advertisements or supposedly helpful links to other items interrupt a flow of text without immediate reason.

Designers respond to the challenge of complex combinations of text and images by using a number of strategies. One, already alluded to, is the grid. This controls the elements on a page so that gestalt principles will link or separate them. Grids offer a way of introducing modularity, and allow a page to use size, for example, both as a schematic indicator of hierarchy, and as a naturalistic indicator of scale. A catalogue of paintings may have headings organized hierarchically by size (period, school, artist). Type size may also indicate the status of the text, with an overview set in larger type and occupying more space on the page, and artists' biographies and painting descriptions set smaller and in narrower columns. When it comes to the images, a different decision has to be made about the scale of reproduction. Should the painting be sized by importance? That may mean that a picture's size is not related to the amount of detail in it. Should the pictures fit common widths or heights, so that they align with horizontal and vertical intervals on the grid? That solution is adopted when pages are laid out by typesetters without specific instructions from a designer. Or should they be sized, as recommended by book designer Derek Birdsall, in proportion to their actual dimensions, so that large and small canvases are reproduced in proportion? Which solution best matches the needs of the reader?

Another decision to be taken by a designer—which can only be taken in collaboration with the writer or editor—is whether to treat pages as simply arbitrary divisions (much as line breaks are

arbitrary in continuous prose) or as semantic units, so that the boundary of a page (or double-page spread or other multiple) is the boundary of a sense unit in the text. This direct visual reflection of the contents was rare in printed books until the mid twentieth century, when layout ideas from magazines began to be adopted in informational and instructional books. Even the earliest manuscripts assisted the reader in knowing when a section or passage started by indicating divisions with large initial letters (in liturgical works, so large that they sometimes occupied a full page). But pre-existing texts are difficult to arrange so that page breaks match sense units. Books which are commissioned to be read in a particular way, such as school and college textbooks, can be planned, page by page, into semantically significant units.

The combination of page-by-page layout and a flexible grid system underlies much contemporary non-fiction illustrated publishing. Book packagers (firms combining design and production skills) such as Adprint and Rainbird McLean in the 1950s and 1960s, and publishers such as Mitchell Beazley (founded 1969) and Dorling Kindersley (founded 1974) made this their trademark. A topic-based double-page spread from a Dorling Kindersley book is open to being read in multiple ways. As a unit, it has a sequential and hierarchical relationship with all the other spreads; it may offer a combination of text (in several configurations), drawn and photographic images, and graphic devices such as rules and tint boxes. All of these elements are planned to reinforce the other, and offer multiple choices to the reader: browse the images, read the continuous text, skim the captions and labels, or be entertained by the curious facts in a call-out panel. The page can support continuous reading, look-up, fact-checking, comparison (by turning from spread to spread). This approach also supports multiple readers: a Dorling Kindersley book typically appeals to children at a visual level, but contains sufficient accurate information in the text to satisfy adult readers.

(The alternative, letting a sequence of text and images flow across pages, brings its own constraints. In the same way that line ends and page breaks in text must be controlled, so must the placing of tables and figures—the print edition of this book was written to fit so that illustrations are correctly positioned relative to the text.)

One of the advantages of print over digital media is the immediate visual organization communicated by layout. Robert Waller shows this by comparing a printed newspaper page with the equivalent story on the newspaper's website (Figure 15). Web pages can offer rich media content, but they are less good at visually relating material for the reader. The printed page organizes the topic: a tint panel runs across the top of the page, grouping the stories under it. A large central image visualizes the 'freeze' metaphor of the main headline. Data are presented in statistical charts. A tint panel at the foot links a set of case studies, while the smaller story on the right is a political analysis. There is even a glossary of terms in column two.

15. (*above*) A page from *The Guardian* showing a group of related items; (*facing page*) the main story presented as a single web page.

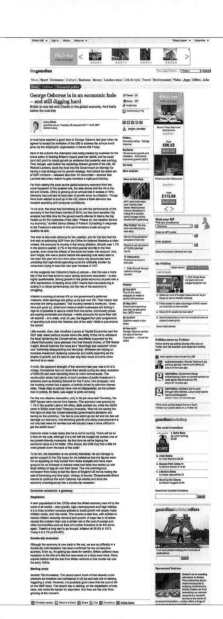

The web page is by comparison a poor affair. Waller points out that only one story is presented, stripped of the statistical charts; only the glossary remains. The connected stories have disappeared; while they are elsewhere on the website, there are no direct links to them. There is no image to give immediacy and appeal to the article. The items in the two right-hand columns are supposedly related, but most of them are generic links to other economics or politics stories, or advertisements (these are likely to have been created dynamically at the point of access). There are many more distractions and diversions for the reader on the web page than the single advertisement on the printed page. In terms of multimodality, options for readers, and its ability to signal the importance of the topic and the newspaper's editorial stance, the printed page is much richer.

The functionality of e-books

Web pages, when designed responsively, can present material for the reader that is optimized for the screen size and orientation of the device they are reading. Desktop screens have sufficient area and resolution to display complex pages, but typically long-form reading on the web is presented in pages of long single columns that the reader must scroll through. Do dedicated e-book readers or e-book software on tablets offer a better reading experience?

E-book readers and e-book software on tablets do allow two important, related affordances. The first is that application interfaces, which on a desktop or laptop computer often frame the text to be read with a distracting array of menus and other windows, are far less overwhelming. The matter to be read can fill the screen, and margins can sometimes be adjusted to suit the reader's preference. The second great advantage is that tablets, being light and small, can be held in a variety of ways in a variety of sitting and standing positions, so that the reader can make themselves comfortable while reading. But questions about the ease of reading (as opposed to the discoverability or searchability)

of texts in electronic formats remain. E-books are either fixed-layout (they mimic the hard page breaks of a printed book) or flowed. Both options are searchable; flowed-layout e-books allow the reader to resize the text without the danger of it disappearing off the edge of the screen, but at the expense of destroying layout features and hierarchical integrity. The relationships between headings and text or text and image are often broken, as these items are not correctly 'glued' together: a heading may appear at the foot of a page without the following text. And while fixed-layout e-books allow the designer to control the text–image relationship, as in a printed book, fixed pages typically have text that is too small to read on all but the largest mobile devices. Annotation, other than simple glosses or references, is poorly handled on all mobile platforms.

Too often, e-books present a window of decontextualized text to the reader, denying them the insight that handling a physical book gives about the scope and overall structure of the work. Too often, linear reading and searching are the only reading strategies that are thoroughly supported. If text composition, typography, and book design are about providing the reader with the means to overcome the linearity of language and enable them to select, turn back, look forward, annotate, and even skip, then the technologies of e-book readers and software still fall a long way short of the printed book.

Wirtschaftsformen der Erde

Zahnrad: Moderne Wirtschaft (Industrie im Vordergrund)
Hammer: Altkulturwirtschaft (Handwerk und Ackerbau entwickelt)
Pfeil und Bogen: Primitive Wirtschaft (Sammeln, Jagen, primitive Landwirtschaft)

Jede Figur 100 Millionen Menschen Schätzung für 1930

Angefertigt für das Bibliographische Institut A.G., Leipzig
Gesellschafts- und Wirtschaftsmuseum in Wien ©

Gesellschaft und Wirtschaft 97

16. An Isotype chart, 1929, 'Economic activity across the World'.

Chapter 5
Picture language

In Chapter 3, we saw that graphic language can be pictorial as well as verbal. For centuries, images were regarded as inferior to language and seen as an embellishment or decoration, despite their undoubted power to transmit information. This held back the development of graphical presentations of data, because numbers in tables were seen as more trustworthy, and the presentation of statistics in charts only began at the end of the eighteenth century. William Playfair (1759–1823) developed and published many kinds of statistical chart, including the time-series line graph and the pie chart. Florence Nightingale (1820–1910) devised the rose chart to give visual emphasis to statistics of military deaths in Crimea. Willard C. Brinton (1880–1957) wrote a classic textbook in 1914, and established standards for the use of statistical charts in business and government. This chapter concentrates on a component shared by data visualization and wider graphic communication, the symbol, a graphic object used to represent a concept, action, instruction, or object.

Symbols can represent concepts, actions, instructions, or objects. We are familiar with symbols being used with or instead of words in contexts such as statistical charts, on hardware and software interfaces, and on signs and other visual instructions. Pictorial presentation can convey meaning where space (and sometimes time) are constrained, for example on traffic signs or equipment

controls. Symbols have a particular typographic quality: they may be presented alone or alongside verbal language, and both situations place specific demands on their design, legibility, and comprehensibility. A symbol is sometimes called a pictogram when it is designed to be representational, and an icon when it is used in situations such as computer interfaces, but there are other definitions of these terms. Here the term symbol is used in a broad sense to encompass icons and pictograms.

How we recognize symbols

Discussing symbols involves thinking about the meaning of signs (in the sense of something that stands for something else in the reader's mind). Because we are dealing with design in the real world, we need not here consider theories that signs are arbitrary: that may be true at a certain level of language (the letters and sounds *c-a-t* have only a conventional, learned connection with our concept of that animal) but it does not help us when we read and respond to visual information at an airport or on a computer interface. How do we recognize the relationship between a symbol we see and what that symbol is intended to mean?

Symbols can have a direct, a transferred, or a metaphorical meaning to the thing in the world they denote or stand for (called the referent). Theories of symbol recognition and use have been usefully drawn together by Alison Black, writing in 2017. In an example she gives, if we see a small drawing of a light bulb on the instructions for a light fitting, we can reasonably interpret it as directly meaning a light bulb. If we see an icon resembling a light bulb on a computer screen, we may interpret it as an indicator of the screen brightness setting, a transferred meaning. Or it may have a metaphorical meaning: a light bulb implies illumination, and illumination implies understanding, so the light bulb could be intended to identify a help option. When symbols are used for transferred or metaphorical purposes they can indicate a function or an action rather than simply identifying a real-world object in

a literal way. On a street direction sign or on a map, a train symbol means a railway station, not the train itself.

Even a symbol that has a direct meaning must have qualities of generalization that a realistic illustration of an object need not have. When a picture directly identifies a particular object rather than a set of objects, it is an illustration, however simplified and conventionalized. Whichever way they relate to the referent, it seems clear that we interpret symbols in a more complex way than that by which we recognize the subject of a picture. Discussing the requirements for successful symbol recognition, Black points out the importance of the context in which symbols are presented, and the need for readers to appreciate possible resultant actions. A symbol's interpretation can be influenced by the interaction between the symbol itself, its context, and the user's previous experience and preconceptions. Overall the process is complex and different from the way we process words, which implies that symbols and words are not interchangeable: indeed, researchers find that symbols are perceived by readers as more 'abstract' than words and (along with photographs) are read more slowly than equivalent words. So why should we use symbols?

Symbols in use: symbol sets

Symbols are efficient because they have controllable spatial attributes, and can be manipulated graphically much more easily than words. They can be arranged into meaningful shapes and assigned colours, and thereby organized into sets that we can recognize as a system. One kind of system presents the reader with individual symbols, or a small number of different ones in combination: road safety symbols are a good example. Symbols on road signs can be designed to share the same dimensions, and fit within a common frame (circle, triangle, square, each with its own meaning; Figure 17, p. 82) in a way that the varying length words *playground*, *bends*, *level crossing* cannot. In an international context, they can remove the need for multiple languages.

Patrol

School crossing
patrol ahead
(some signs
have amber
lights which flash
when crossings
are in use)

Frail (or blind or
disabled if shown)
pedestrians likely to
cross road ahead

No footway
for 400 yds

Pedestrians
in road ahead

Zebra
crossing

Safe height
16'·6" (5.0 m)

Overhead electric
cable; plate
indicates
maximum height
of vehicles which
can pass safely

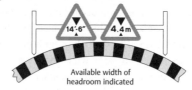

Available width of
headroom indicated

Cattle

Wild animals

Wild horses
or ponies

Accompanied
horses or
ponies

Cycle route
ahead

Ice

Risk of ice

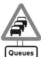

Queues
likely

Traffic queues
likely ahead

Humps for
½ mile

Distance over
which road
humps extend

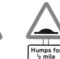

Hidden dip

Other danger;
plate indicates
nature of
danger

Soft verges
for 2 miles

Soft verges

Side winds

Hump bridge

Ford

Worded warning
sign

Quayside or
river bank

Risk of
grounding

17. Triangular warning signs used in the UK, including signs where
a verbal message qualifies or replaces a symbol, from *The Highway
Code*, 2015.

We encounter this kind of symbol as part of a set (for example, the symbols seen by the driver on the dashboard of a car, or those encountered by a traveller at an airport). To make effective sets, we should consider the variables that can be applied to symbol design: there is a range from concreteness to abstraction, and there are degrees of visual complexity from simple to complex. The train symbol is concrete; the forward arrow on a sound interface indicating 'play' is abstract. The children drawn as silhouettes on the British 'school' road sign are simple; Apple's Mail application symbol, a naturalistic postage stamp, is complex. Members of a set of symbols should represent related objects or actions, should be based on related ways of interpretation (direct, transferred, or metaphorical), and should share visual conventions in their degree of concreteness and visual complexity. This way, within a particular context, we can build up a secure means of comprehending symbols through recognition and interpretation.

As well as those that we encounter in everyday life, symbols (especially hazard and safety symbols) exist for many areas of technology. The International Standards Organization (ISO) issues guidelines for the testing of symbols, as well as maintaining an online database of symbols which meet its criteria, many of which are mandated by international agreements. For safety symbols, ISO identifies not only the hazard and the need for the symbol, but also the behaviour that it is intended to prompt, and its required location. These help define the graphic characteristics of the symbol, including any colour coding. ISO sets a higher recognition rate for emergency symbols (86 per cent correct recognition of the symbol alone, with no supporting text, with fewer than 5 per cent incorrect responses) than for information symbols (66 per cent correct recognition).

Research indicates that recognition is faster for simple symbols than it is for complex ones, and that this difference does not diminish with exposure to the symbols. Overall shape identification is important: abstract symbols with distinctive

silhouettes (such as a triangle or a circle) were searched faster than concrete symbols with similar silhouettes. Familiarity is important in the recognition of symbols, and research subjects report a liking for symbols they are familiar with. Attempts have been made to identify features that make symbols problematic in cross-cultural contexts, such as those that include Latin letters or hand gestures. However, some research notes that such symbols, when used in an interface with which subjects have familiarity, such as Microsoft Word, are easily recognized, suggesting that the cultural appropriateness of symbols is complex, something that should not be taken for granted, and requires specific, contextual testing. The importance of familiarity reinforces the need to support symbols with supplementary text when we cannot be sure of that familiarity. This is particularly true of interface design. As with words, it is important to space symbols correctly relative to one another, with regard for their use. On a touchscreen interface, arrays of symbols should be small (no more than 5×5 items), but the symbols need to be big enough, with sufficient space between them, to allow accurate finger placement.

Probably the most important guideline for designers that Black identifies from research is not to place too much reliance on their use alone. Whether used as icons on digital interfaces or on signs or charts, symbols are not simple substitutes for words and, in most cases, cannot be expected to stand alone. Supporting symbols with text assists meaning.

Symbols in use: presenting data

When Brinton established technical guidelines for the visual presentation of statistics, suggesting good practice for graphs, he was aiming at a professional, expert audience: after all, he lectured at Harvard and his book was published in the Industrial Management Library. The challenge of explaining statistical data to non-experts and engaging the ordinary citizen was altogether greater. It was exactly this that Isotype (International System of

Typographic Picture Education) attempted, to develop a more systematic approach to representing statistics by using symbols of a different kind, symbols that could be combined in rows to represent quantities, much like pieces of type. Isotype was devised by the Austrian philosopher Otto Neurath (1882–1945) as a means of explaining social statistics after World War I. Isotype charts displayed information using repeated symbols instead of the lines or bars of traditional graphs, with the aim of looking less technical and more easily understandable. Neurath emphasized the need to make an exact relationship between the pictorial representation and the quantity itself.

Brinton had, in passing, drawn attention to a problem with pictorial charts. Traditionally, these used relatively naturalistic drawings and simply enlarged or reduced their height to represent a change in quantity. As this changed their area as well as their height, reckoning the actual values visually without reference to confirmatory figures was impossible. In contrast, each Isotype symbol both signified the item or activity being quantified, and represented a specific quantity (which varied from chart to chart, but was always a round number, such as 50). When these identical symbols were put together in rows or columns, values could be expressed more accurately, albeit with some rounding depending on the units chosen for each symbol. The pictorial approach gave a sense of concreteness and immediacy to statistics, which chimed with the progressive educational aims of Neurath and the social democratic municipality of Vienna, where it was developed from 1925 at the Social and Economic Museum. As Neurath explained, 'Words make division. Pictures make connection.' The requirement that Isotype symbols combined well in rows or columns determined aspects of their design: their outlines often nearly fill a rectangular space, so that rows cohere, but with sufficient internal white space so that they are distinct enough to allow the number of symbols to be counted. The striking visual quality of Isotype symbols owes much to the graphic skill of their principal designer, Gerd Arntz (1900–88), and has been influential

in the development of other symbol systems, such as those for international transport and the Olympic Games.

As well as imposing the rule about representing quantities by multiple symbols, Neurath also imposed rules similar to (but not always the same as) Brinton's in relation to reading direction, the axes used for time and quantity, and the relative salience of elements. Given that traditional time-series and bar charts can plot data with extreme accuracy, what are the advantages of Isotype charts? In addition to immediacy and concreteness, Isotype symbols can be counted, and this helps the reader to make judgements about relative proportions: it is easier to compare a row of three red symbols with a row of four green symbols and to conclude that the red quantity is three-quarters of the green quantity than it is to compare the equivalent lengths of two bars with the same degree of certainty. This is because symbols are typographic in a way that graph lines and bars cannot be: they are modular, creating their own grid, and hierarchical, in that symbols can be related to one another.

In a limited sense, Neurath was inventing a picture language (he called it a 'helping language'), because the symbols were gathered in a 'picture dictionary' and he established syntactical rules by which they could be combined to express connected ideas. There were principles for layout and how charts could combine several sets of statistics to tell a story. Symbol combinations are shown in a chart of different kinds of economic activity across the world (Figure 16, p. 78). Symbols represent each type of activity: a cogwheel represents a technological economy; a hammer represents one based on handcraft and agriculture; and a bow and arrow, one still based on hunter-gathering. These are combined with symbols indicating people in different countries—depicted by the same basic figure but with different clothes and hats. (We may find some of these representations stereotypical to the point of insensitivity today, pointing to the problem of representing human diversity recognizably but respectfully in symbol form.)

It is worth noting, in relation to advice about the use of symbols in combination with words, that Isotype charts never consisted of symbols alone: each was treated as a typographic whole, with a headline, explanatory text, and labelling. The symbols provided visual immediacy and worked with the text to convey meaning.

Isotype principles can been seen as working with gestalt theory, and also relate to the analysis of visual variables for representing data originally proposed by Jacques Bertin (1918–2010) and added to by others. These variables include position, size, orientation, and shape; hue, saturation, and brightness; and focus and texture. Isotype was strict about the application of most of these. Position and orientation were determined by reading order, or by conventions for indicating time or geographical distribution; size was indicated by the use of multiple symbols of equal size; bright, saturated colours were used for data symbols to increase their salience, and soft, desaturated colours were used to make contextualizing background images recede; the charts were even in relation to focus and 'flat' in terms of texture. From a gestalt perspective, Isotype charts rely on the similarity principle (we discriminate between symbols because of their similarities and differences) and the grouping principle (we read multiple identical symbols as adding up to a whole value). When symbols are superimposed on map backgrounds, then the proximity principle is used to locate them correctly to the relevant country.

Looking at Isotype principles and examples can provide some general advice for data presentation. Use a consistent graphic style when creating symbols, so that relationships between them are clear; if appropriate, combine symbols to generate a third meaning; apply a consistent use of colour to enhance or reduce salience; use reading direction and chart axes consistently; prefer digital sampling (such as bar charts) over analogue tracing (such as a graph line) when a value is being shown at discrete intervals; avoid area comparison issues by avoiding pie charts or representing quantities by circles, and instead

use repeated symbols for quantities. From the standpoint of the graphic language schema discussed in Chapter 3, Isotype charts are interesting because they combine so many methods of configuration and modes of symbolization, and show the communicative possibilities of such complex combinations. Finally, the process used by Isotype still has lessons for designers today. Marie Neurath (née Reidemeister; 1898–1986) identified her pivotal role of imagining how statistics should be presented on a chart as that of a 'transformer'. This was a thinking role, controlling but slightly apart from the drawing of symbols. The striking designation points at the real effort required in both researching and understanding information, considering how best to present it for the public, and grasping the production methods that can best give it form. Isotype accepted and embraced the fact that all designed objects are mediated by the designer for the user: its achievement was to imbue this role with a high moral and educational purpose.

Data and visual responsibility

Isotype's approach that data should be simplified and presented using symbols did not meet with universal approval. Data purists such as Edward Tufte value exactness and complexity in statistics. In his writings since 1983, Tufte promotes useful concepts such as the data–ink ratio (essentially, that most of the ink on a chart should be expended on the objective data, and much less on framing and organizing features of the chart, such as axes and grid lines, or prettifications he calls chartjunk). He has popularized some classics of data visualization, such as Charles Minard's representation of Napoleon's Russian campaign (1869). He sees the presentation of simplified data for public consumption as problematic, and has criticized charts which use pictorial elements (albeit examples with much less rigour than Isotype). Considering the two approaches, Neurath's work was in an educational context, while Tufte, like Brinton (to whom he does not refer), is suggesting norms for the professional presentation of data. Isotype sought to

make the general point of a set of statistics clear, and saw its charts as supporting verbal arguments: Tufte's aim is to allow the reader to dig deeper into the unmediated data. But Isotype was equally rigorous in avoiding 'junk' pictorializations; indeed the rationale of the modular, measurable symbol was to provide a way of escaping the vagaries of pictures that alluded to but did not reveal the data.

The hope of Brinton that a 'grammar' of data presentation could be established and that of Neurath that Isotype was an 'international picture language' (albeit only in the sense that it had some basic syntactical rules) laid the ground for the systematic use of graphic symbols after World War II. Beginning in 1931, a sequence of conventions on international road signs established a wide currency for primarily pictorial signs. In the USA, publications by Rudolf Modley (1906–76), who had been an associate of Neurath, promoted symbols in economic and business publications. The industrial designer Henry Dreyfuss (1904–72) made an influential collection, *Symbol Sourcebook* (1972), after working on standardized international labelling for farm and oil drilling equipment. Information symbols began to take their place in the designer's toolkit. In 1974 the American Institute of Graphic Arts published a set of symbols for use at airports and railway stations. In Britain, road signs based on the European model but noticeably simpler in drawing appeared in 1965, with symbols designed by Jock Kinneir (1917–94) and Margaret Calvert. Together with the database of symbols managed by ISO these constitute an established lexicon of symbols that has widespread familiarity, if not fully constituting a 'picture language'—a term that Neurath, a philosopher with a deep concern for language and logic, was both attracted to but ultimately unconvinced by.

SOMEWHAT CONTRE L'ESPRIT OF THIS MOUTHPIECE, THIS WRITER HAS CHOSEN NOT TO COLLABORATE WITH ITS DESIGNER

18. Whose words are these, the writer's or the designer's? From *Emigre* 35, 1995.

Chapter 6
Emotion or information?

We are surrounded by a typographic environment. Typography is present not just in the printed matter that we read, but also in all our interactions with computers and mobile devices, with street signs and shop fronts. Architects add letters to buildings; brands present themselves with distinctive word marks and alphabets. Typography has multiple personalities. As well as identifying and imparting information, typography is associative, and designers use it to influence our view of the messages we are reading. In this way, typography can be considered a creative endeavour:

> Type is saying things to us all the time. Typefaces express a mood, an atmosphere. They give words a certain colouring. (Rick Poynor)

Typography is also the mechanized presentation of language. In this way it is subservient to the structures of the messages it presents:

> Nobody should forget that typography is the least free of all the arts. None other serves to such a degree. It cannot free itself without losing its purpose. It is more strongly bound than any other art to meaningful conventions and the more typographers heed these conventions the better their work will be. (Jan Tschichold)

How can we reconcile these different aspects of typography?

Design as an ideal and as a compromise

The wayfinding designer Paul Mijksenaar attempted to describe
the aims and outcomes of the design process by considering the
relationship between function and aesthetics. He looked back to
Vitruvius' three attributes of architecture: durability, usefulness,
and beauty, which he translated into reliability, utility, and
satisfaction. By profiling designed objects or systems against
all three of these attributes, he sought to establish priorities for
individual products that were specific to their making and use,
thereby avoiding 'dogmas'. By this he meant either too narrow an
interpretation of functionality on the one hand, or of aesthetic
value on the other. He concluded that 'function can have any form'.

The writer on design David Pye (1914–93) divided the designed
world into things for use (he cited buildings, vehicles, tools, and
clothes) and things for contemplation (pictures and sculpture).
He thought that the word 'function' should not be regarded as an
intrinsic quality of a designed object, for example, because of its
shape; the test of whether an object is functional is in the hands
of the user. A thing is functional because it does what the user
wants, not because it is made with a certain look or feel. Design for
reading seems to sit firmly in the 'things for use' category, but, like
much useful design, its products cannot escape sharing many of
the formal visual qualities of those 'things for contemplation'.

Pye sought to cut through this paradox, that we want to design
things to work but inevitably design things to give us pleasure
when we contemplate them, by pointing out the limitations of
what we can and can't design in a physical world. If a designed
object cannot be perfect, we must choose its achievable attributes:
and it seems that imparting beauty (or 'workmanship', or 'design
for appearance'), although dismissed as useless work, has always
been high on the list of what is both desirable and what can be
achieved. On fulfilling the user's requirements for functionality, he
takes the example of a dinner table, and suggests:

Nothing we design ever really works. We can always say what it ought to do . . . Our dinner table ought to be variable in size and height, removable altogether, impervious to scratches, self-cleaning, and have no legs. . . . Every thing we design and make is an improvisation, a lash-up, something inept and provisional.

By improvised and provisional, Pye does not mean badly designed, far from it; but he is pointing out the distance between what is really desirable and what we can do with the limited resources at our disposal, and to the intractability of much physical production. This needs to be considered alongside the superabundance of opportunity that the digital word seems to offer: the mobile phone, originally just a phone, is now our most powerful personal digital device, our highest resolution camera, and our point of access to almost all the world's recorded music.

Taking a line of thought from Pye, a book, for example, should simultaneously open flat without the need for restraint when we want it to, be capable of being held in one hand, be large enough to show images at a realistic scale, be light and convenient to pop in a bag to read on the train, have type that can be read in any light, never scuff or tear—oh, and be cheap to buy, too. We can see that these are contradictory attributes, and no real book can promise them all. What a well designed book can do, if the designer has done their work, is to fulfil the most likely needs of its most likely readers: the particular profile of reliability, utility, and satisfaction required of it. A smart phone, for all its amazing technologies, is still a Swiss-army-knife affair: we accept the trade-off of its cramped virtual keyboard and limited battery life for its host of apps. Typographers have always been aware of the constraints on design and the trade-offs required: in the days of metal type, you were forced to work with the existing sizes of type available, and build designs around them. There are still physical constraints in print: the grain direction of paper determines how easily and neatly sheets can be folded and bound, and this will influence the choice of format. So compromise and

accommodation, while still seeking the ideal, is the natural state of design.

In fulfilling the needs of its readers, our imaginary book will be constrained, not just by economy but also by style, in the sense we have encountered in Chapter 4, the need or expectation that a piece of design will fit into a recognizable genre, or risk being misunderstood by its readership. This has been put rather grandly by the engineer Marco Aurisicchio: 'no design works unless it embodies ideas that are held in common by the people for whom the object is intended.' Pulling back from individual genres, we can perhaps see three overarching reasons for written material: for pleasure, for information, and for persuasion. Design needs to address all three needs.

Reading for pleasure

To immerse oneself in an writer's work, with no concern to take any action as an immediate consequence of the reading act, is perhaps the closest we can get to reading for its own sake. This is the kind of reading that the publicist Beatrice Warde (1900–69) wanted to support when she talked of typography as a 'crystal goblet'—a pure, transparent vessel that hides none of the content and imparts as little of its own character as possible; or the otherwise-revolutionary designer Jan Tschichold, when he wrote in 1928 that 'the old form of the book is perfectly suitable for such literature . . . there is no need for change . . . only modifications in traditional book design are possible.' They had in mind a page, possibly in a novel, that has no hierarchies of text, an even block of linear-interrupted prose. But beyond its page design, such a comfortable book requires a large number of physical qualities to be just right, both in the book itself and in the reading environment. In this way we can see that the ideal page size, margins, and type size need to be allied to an ideal paper shade and a binding that opens perfectly—and as important are the comfort of our armchair, and the quality and direction of our reading light.

Both Warde and Tschichold, of course, knew of and promoted good design for all manner of complex printed matter, so their concern for the calmness of the ideal book page was a concern for the reader, not mere fuddy-duddiness (Tschichold in the same book printed heavy black bars beside the paragraphs he wanted his readers to notice most). The opposing view to the crystal goblet analogy is that we cannot prevent the form of the book (or whatever object) coming between the text and the reader, which we will come to again later in this chapter.

The most urgent form

The German new typography of the 1920s that Tschichold developed and promoted aimed at reforming design for the modern age, primarily to communicate information. He believed that typography should eschew decoration and instead match *inner organization* (the organization of contents) and their *outer organization* (the means of typography)', and thereby ensure that a communication appeared 'in the briefest, simplest, most urgent form' (1925). In his books he showed many before-and-after examples, often radically simplifying advertising and promotional material to show how much more 'urgent' the message could be. In particular, he acknowledged that the photograph was the contemporary form of illustration, and that in all kinds of printing new ways had to be found to make type and photographs to work together. His solution was to stop treating photographs as if they were wood engravings—small, laid out symmetrically, and with fancy borders—and use them as part of dynamic asymmetric compositions. Tschichold argued strongly for the adoption of standards (such as the German, later international, standard paper sizes), and of planning rational design systems—something he was able to put into effect in his work standardizing the typography of Penguin Books (1947–8).

The ideas of the European avant-garde moved to the USA after 1945, and another European modernist influence on American

design for commerce in the 1950s was the Czech designer Ladislav Sutnar (1897–1976), whose American work was firmly corporate: his studio designed business identities, catalogues, exhibitions, and stationery systems. His work, although quirky, was informed by the need for modularity and standardization, and in particular displays an understanding of visual flow from page to page. The modernist style was taken up by advertising and corporate designers in America from the end of the 1950s: advertisements such as Doyle Dane Bernbach's campaign for Volkswagen (1959–) were stripped down to a simple arrangement of provocative headline, brisk copy, and a black-and-white photograph. In their deployment of white space and the consistent use of Futura type, these advertisements were a far cry from the folksy, illustrated ads so effectively mocked by Marshall McLuhan in *The Mechanical Bride* (1951). The 1960s also saw the rise of the typographic word mark in corporate design. Often set in one or other weight of Helvetica, these logos replaced traditional graphic forms, such as the florid signatures that announced the products of Ford or Kellogg's. But despite advertising's adoption of the visual ideas of modernism, there were voices of dissent.

Calls to action

Ken Garland's *First Things First* manifesto, collectively signed in 1964 by a group of visual communicators, accused advertising of claiming to be 'the most lucrative, effective, and desirable means of using [designers'] talents', and sought to draw design students in particular away from that industry's grasp. (The manifesto was rewritten and reissued by *Adbusters* magazine in 1999.) It went on to argue that it did not 'want to take any of the fun out of life', but that there were more socially responsible areas of design activity than 'the high-pitched scream of consumer selling'. These included signs for streets and buildings, books, instruction manuals, educational aids, films, and scientific publications—a set of design challenges that today we might bring together as 'information design'.

In 1964 many of these things were only just beginning to come into the range of the (newly art-school educated) designer, having long been handled by engineers, production managers, and printers themselves. In this sense the manifesto was part of the British design profession's coming of age, but its open-hearted sense of social responsibility and its desire for design to make a lasting contribution to society strike a powerful chord. Was this sense of responsibility found in the emerging discipline of information design? Communications expert Karen Schriver identifies the three specific needs that a reader has of a piece of information: to be able to assess, to do, and to learn to do. Information design, then, needs to support reading which results in an action, a sequence of actions, or even a new behaviour. In this way it is different from reading for pleasure, and actually more akin to design for persuasion.

The similarity between advertising and information design is that they both include a 'call to action'; the difference is that the action from an advertisement usually involves a suspension of rational thinking and an acceptance of the advertiser's claims, whereas in information design the action, however persuasively presented, should be a rational choice on the part of the reader. To use Mijksenaar's analysis, the profile of a piece of information design should always be strong on utility, while an advertiser may be able to rely on generating a feeling of satisfaction. This puts a particular onus on the designer: if they are truly empowering the reader, they have to design for multiple appropriate and rational responses, whereas the advertising designer can declare with a straight face that 'one size fits all'. Structurally, this means that much of persuasive information design is like an algorithm—presenting the path by which a reader comes to decide that *this* action is the right one for *this* set of circumstances, so that they can navigate complexity.

As we've seen when discussing language and house style, the rhetorical tone of voice of the text is as important as its typographic

presentation in these circumstances. This is recognized in the various plain-language and simplification initiatives that have grown up to make necessarily complex items such as legal documents more accessible. The information designer and writer need to work in the closest collaboration if clarity in such documents is to be achieved.

Because we can

The implied closeness to persuasive design also indicates that the rhetorical approach of information design need not (indeed maybe cannot) be neutral. Or rather, it may be neutral in presenting alternative options fairly, but it still needs to engage and guide the reader through its pages—concern for the reader is the essential stance of this kind of typography. We can define its rhetorical approach through Tschichold's dicta of matching the appearance to the content and presenting information in 'the most urgent form'. This is why the British typographic critic Robin Kinross argued in 1984 that Bonsiepe was mistaken in characterizing a classic piece of information typography—the railway timetable—as being 'innocent of all taint of rhetoric'. Kinross shows two different presentations, one fusty with rules and boxes, the other presented cleanly with the addition of a route map; both designs have a rhetorical aspect. The latter aligns its originating organization with the reduction of forms, removal of ornament, and content-driven arrangement that are key components of modernism and of the new typography; the former implies an older sensibility, more concerned with fitting information into predetermined patterns. Both immediately announce something of their originating organization's approach to the traveller: after all, in a visual world, we only have the immediate impact of a document on our eyes from which to form a judgement. The branding designer and information designer both need to be aware of the rhetorical value of their designs. They both have the same tools and they share an aim of presenting their client's message in the best possible light.

We certainly cannot escape designing in the world we live in, a world where many of our daily interactions are commercialized, and where, to slightly rephrase Karl Marx, 'the ruling ideas are those of the ruling class'. We can ensure that our design objectives are more than simply commercial, and that our professional position is an open, pluralist one that regards the most likely reader's most likely needs as the purpose of all our work. And, as Pye argues, we should make anything we design invoke a sense of visual pleasure as part of this endeavour, even when many other desired objectives cannot be realized, *because we can*.

Typography and wider culture

Typography has always engaged with the wider visual culture of the day. Indeed, the various printing processes used to multiply images—copper engraving, etching, lithography, wood engraving—were used by artists as well as practical printers, with considerable visual overlap. As a result, stylistic developments in typography can be described in relation to Western art movements: Renaissance, baroque, neoclassical, art nouveau. A direct and dramatic influence of visual artists on the form of typography came with modernist movements at the beginning of the twentieth century. The designer Herbert Spencer (1924–2002) explains that the modernist revolution

> was carried through by painters, writers, poets, architects, and others who came from outside the printing industry. They seized on printing with fervour because they clearly recognized it for what it properly is—a potent means of conveying ideas and information— and not . . . a kind of decorative art remote from the realities of contemporary society.

The artists of the various modernist movements sought to convey ideas with words and photographs are well as through painting and sculpture. Their innovative use of collage, montage, elemental forms, primary colours, and the dynamic use of space could be

rendered through graphic design and typography, and multiplied by printing. In many cases these experiments cut right through typographic norms—Dadaist publications throw together type with a disregard for linear reading, in an attempt to recreate the emotional power of the sounds of language. Designers such as Jan Tschichold, however, saw the graphic purity and drama of the modernist visual vocabulary as a way of liberating typography. This vocabulary of elemental forms, primary colours, and geometrical grid systems offered a way of organizing type that was both logical *and* visually exciting, and allowed the integration of type and photography in a new and practical way.

Did typographic modernism lose its way in the post-1945 period, and become simply a one-size-fits-all corporate style? Typographic modernism certainly took a particular course, aligned more to the development of modernism in architecture than in literature. While literary modernism embraced techniques such as simultaneity, word-play, and the disruption of narratives, typographic modernism rejected ambiguity, adopting an almost neoclassical severity. In doing this, typographic modernism developed a formalist, rather than an anti-form stance. This was the accusation of advocates of a more eclectic, postmodernist approach. Postmodernism spread to graphic design and typography in the 1980s, with clear stylistic and conceptual links to other areas of postmodern expression in architecture, art, fashion, and pop music. Designers in all these fields played with genres in a knowing way, expecting their readers to be aware of their visual references. As well as recognizing the fact that 'the medium is the message', they often gave the visual impact of the medium priority over the clarity of any text it might contain—after all, the look of the medium was what the reader immediately responded to. This threw a rather awkward spanner in the narratives of those who considered modernism, in the post-1945 international version of the Swiss approach to design, as the apogee of typographic styling. Postmodernists such as Jeffery Keedy claimed that modernist typography was a 'zombie', dead but still claiming adherents; in

turn, they were criticized by typographers such as Robin Kinross for designing for an audience of like-minded designers, and for producing design that was difficult for a wider public to relate to. Did this debate reveal a degree of introversion within typography and graphic design? After all, concrete poets and conceptual artists had been engaging with typographic language for decades, and those whose practice lay in publishing contexts had long played with genres and subverted readers' expectations as part of that practice—as evidenced by publications such as the multimedia magazine *Aspen* (1965–71). And typographic postmodernism's playground was music, youth culture, and fashion, all areas whose audiences are expert in recognizing styles, allusions, and trends; it was hardly an assault on the legibility of railway timetables or wayfinding systems.

So while mapping developments in typography to art historical movements can help explain something of the visual culture in which printed objects were produced, it needs to be put alongside consideration of how typographic design developed, at the same time, in response to the changing demands of authors and readers, or indeed to intellectual ideas outside the visual arts. The focus of some graphic design histories is on a limited canon of graphic objects that have achieved iconic status, by virtue of their authorship or by seeming to represent their period. Such selections provide a series of signposts for the beginner, but the best writing on graphic design takes a critical approach that understands the complex interplay of forces in visual culture. Broad, international historical surveys by Richard Hollis and visual criticism by Rick Poynor fall firmly into this category. The role of design criticism is also to point to inconsistencies and wishful thinking in the practice of the subject. Edited by Rudy VanderLans, the magazine *Emigre* (1984–2005) was an outstanding exponent of this approach, a slap in the face for glossy compendiums of commercial and advertising design 'masterpieces'. By inviting writers to interrogate design, and then designing their texts in ways that brought out discrepancies and paradoxes between content and presentation,

Emigre reminded both parties (and their readers) that *any* design frames the reader's view of a written text. The claim by Adriano Pedrosa in *Emigre 35* that 'design kills writing' is a dramatic but welcome overstatement of the truth that all design intercepts and re-presents writing, and thereby changes it: the writer's words can only be read through the typographer's design (Figure 18, p. 90).

Learning from the everyday

What alternatives are there to seeking a canon of designed artefacts or heroic practitioners? Historical approaches to typography that focus on purpose, use, and readership (while fully recognizing the visual, cultural status of the objects and the context in which they were made) may show us cogent differences and similarities between the printing of the past and the multimedia typographic universe of today. Some of this work was done in the 1950s and 1960s, when John Lewis (1912–96) and Maurice Rickards (1919–98) turned to collecting and cataloguing printed ephemera—'the minor transient documents of every day life'—and helped preserve and popularize a stratum of printing below the books and periodicals that were assiduously collected in libraries, but which in reality constituted the bulk of printed matter that the population at large encountered: price lists, menus, maps and timetables, circus and theatre bills, packaging labels, tickets, and receipts. A parallel can perhaps be drawn with the way that in their 1977 book *Learning From Las Vegas*, the architects Robert Venturi and Denise Scott Brown looked at the vernacular, blatantly commercial buildings of the Las Vegas Strip in order to understand urban environments in ways that were not accounted for by purely 'rationalist' modernist design.

Printed ephemera can range in style from the visually sophisticated (that is, matching the dominant visual ideas of their time), through the rebellious (again, sometimes aligned with alternative cultural movements), to the quite untutored and ad hoc manifestations of what ordinary people thought printing

should look like. Looking at ephemera lets us trace ideas about the relationship of graphic form to language with an evidence base of voices and approaches far wider than those of books or even magazines, and forces us to confront the visual meaning of items which don't have a convenient, prejudged, iconic status.

The look of the thing

How can we evaluate typographic design where the visual embodiment, the look of the artefact, and perhaps not the text, has the primary communicative function? These are objects whose profile, in Mijksenaar's analysis, lays most emphasis on the reader's satisfaction, their emotional response. Such things are not new: a medieval book of hours was as much (perhaps more) of an object for its owner to gaze upon and enjoy than a religious text to be read. Precise visual relationships were immensely important to highly practical book designers such as Tschichold and Hans Schmoller (1916–85). Both would probably have concurred with the dictum of type historian Stanley Morison (1889–1967) that 'the enjoyment of patterns is rarely the reader's chief aim', but that did not prevent them from designing pages where the placement of every element is judged to perfection.

In contemporary graphic design, the typographic work of Jonathan Barnbrook straddles commercial work and personal expression, but always makes the visual form embody the idea to be communicated. His work for David Bowie (1947–2016) on the album *Blackstar* (2017) offers a visual analogue of Bowie's songs. Barnbrook uses specially created typefaces, star symbols and patterns that have a particularly typographic quality, and precision black-on-black printing techniques. They seem to resonate with Bowie's elliptical lyrics rather than explain them or simply present them to be read (they are barely legible). His typefaces, such as Bastard, an extreme reworking of black letter, show technical skill and historical awareness. They are fully functioning digital fonts that are commercially available, but which reflect a highly personal

view of design history. He uses them in *Barnbrook Bible* (2007) in a way that echoes the jewel-like coloured pages of a book of hours, and resembles the Victorian bible of decoration, *The Grammar of Ornament* by Owen Jones (1809–74). This is typographic pattern-making that is intended to be enjoyed for its own sake.

The use of typography by conceptual and visual artists can be either abstract and distancing or highly concrete. The work of Lawrence Weiner often take the form of typographic texts, applied at large scale on to walls or glass panels, and set in industrial-looking typefaces. Weiner was influential in the development of conceptual art, where an artwork consists of 'language + the material referred to'. Such an artwork need not have a definite physical form: instead it can be a concept with which the viewer engages. Consequently the typographic presentations used by Weiner have a neutral, almost accidental quality. Although the arrangement of the type may emphasize or reflect in a slightly obvious way the meaning of the words, the visual qualities of the typefaces used do not always seem to be part of the message. In contrast, Hansjörg Mayer, who has a family background in printing, builds images from letterpress-printed type, with repetition and overprinting emphasizing the multiple quality of a printed product. In his work, as with the work of letterpress printer Alan Kitching, the materiality of type, and its imperfections, comes to the fore.

Over the course of the twentieth century, books produced by artists became less concerned with the reproduction of images, and more with the making of texts, as the acts of writing, production, and publishing became central to art practice. In this area we can see something of how text typography is exploited by visually aware artists who are not primarily typographers, and how quite subtle disruptions of the norm can make strong visual statements. Some contemporary artists choose to present work using ordinary materials of commercial publishing. Ed Atkins's *A Primer for Cadavers* (2016) is a collection of unsettling essays

that has the appearance of a classy but still normal paperback. This use of a superficially familiar visual genre has a parallel with his practice in videos, where he uses all the hyperreal, high-definition technologies of television advertising to make disturbing narratives. In a work that juxtaposes a familiar form with impenetrable content, Jeremy Deller collaborated in 2016 with typographer Fraser Muggeridge to produce an edition of *Utopia* by Thomas More (1477–1535). It is set entirely (and therefore unreadably) in More's invented Utopian alphabet—a series of geometrical signs which replace the normal twenty-six letters of the Latin alphabet. Again, the physical book, in its paper and binding, feels like a contemporary paperback—albeit one with a Day-Glo yellow and pink cover.

Choices made by graphic designers in their more personal work, and by artists themselves or in collaboration with designers, are not the same as those made by designers working for industrial or commercial clients, but can be equally rationally based, as they seek to embody the essence of the work through typographic means. Genres and norms of legibility may be purposefully subverted, and typeface choices deliberately eccentric. In these ways, designs that are intended to be looked at rather than read offer conventional typographers a means of questioning their rationality as practitioners, and provide further evidence that the visual form of printed communication is never accidental.

Gray fox jumps the dog

Gray fox jumps the dog

Gray fox jumps the dog

Gray fox jumps the dog

Gray fox jumps the dog

Gray fox jumps the dog

Gray fox jumps

minimed bdpq

|||||||||||||||

minimed bdpq

| |||| ||| || ||| |

minimed bdpq

||||||||||||||||

19. (*top*) Differences of weight, stroke contrast, aperture, and closeness of character spacing make 'equalizing' different typefaces difficult. The typefaces shown (*from top*: Helvetica Neue, Fresco Sans, Century Gothic, Times New Roman, Miller Text, Tisa, Courier New) are sized to have equal x-heights. (*bottom*) Differences in homogeneity and heterogeneity between serifed (Tisa), geometric sans serif (Century Gothic), and humanistic sans serif (Fresco Sans) typefaces.

Chapter 7
Making typography legible

Reading is a complex process whereby we identify and transform a written message into meaning, so that we are able to respond to it. Where do we go to find out how to evaluate how easy a piece of typography is to read? Typographic practitioners have a store of tacit craft knowledge, but may be unable to explain underlying principles; indeed, they may know how to design things that work, but have misconceptions about *why* they work. Investigations by psychologists into reading can identify the factors that make type legible under different circumstances, and suggest the best solutions to facilitate reading. Designers and psychologists working together can focus on user needs and, through iterative design, develop the most appropriate solutions.

Printers began to write about their craft in the seventeenth century, but well into the nineteenth century such manuals were only descriptions of the techniques of making type and printing: discussion of design is noticeably absent. Readers did notice the type they were reading: the new styles introduced by Baskerville and the Didots in the eighteenth century provoked discussion about how comfortable they were to read. At the end of the nineteenth century, discussion of how to do typographic design came from two directions. One was the detailed codification of typesetting practice, for example by Theodore Lowe De Vinne (1828–1914) and in *Hart's Rules for Compositors and Readers at*

the University Press, Oxford; the other was the sustained critique of typographic standards from the Arts and Crafts movement, and from William Morris (1834–96) in particular. But *Hart's Rules* was procedural, explaining how, not why you print something in a certain way: it did not mention legibility. Morris certainly preached why you should print something in a certain way, but his argument was a complex one that regarded a particular visual style, inspired by the medieval, as supporting his vision of morality in art and industry. This division of typographic writing into either detailed description or stylistic argument set something of a pattern. Craft knowledge was passed on, but many practitioners resisted scientific investigation into the basis for this knowledge.

The mid nineteenth century saw the first attempts to analyse the visual processes of reading scientifically. The French ophthalmologist Louis Émile Javal (1839–1907) described eye movements in reading, observing that, rather than moving smoothly along a line of text, readers' eyes make short rapid movements (saccades) intermingled with short stops (fixations). You can see saccades for yourself if you ask a friend to hold up and read from a sheet of paper in which you have punched a small hole. Peer through the hole and you will be able to see the jerky movements of their eyes. We move our eyes during reading partly because only the tiny central area of the retina (the fovea) can discern fine detail—and at normal reading distances only six or seven letters fall inside this area. A word longer than this will mean that some of its letters fall into the less-acute area of the retina. To recognize letters efficiently we have to keep them on or near this central area, and so each saccade is about seven to nine characters in English. But saccade length varies by script and language (it is only about two characters in a dense script such as Chinese, although more characters fit within the foveal area). This indicates that saccade length is limited more by information processing than by visual processing. We also fixate for shorter periods on familiar high-frequency words and longer on unfamiliar low-frequency words. A different kind of movement is required of the reader to

return their eyes from the end of one line to the beginning of the next: a return sweep which is at an angle to the lines being read. The longer the line and the tighter the spacing between lines, the smaller the angle of the return sweep required of the eye will be. If it is too small, the angle can be misjudged, and the reader may skip a line and begin reading the next one. This is why it is important that the amount of space between lines is increased in proportion to line length.

Guidelines for legibility

The relationship of line length to line spacing was one of the variables identified by the designer and legibility investigator Herbert Spencer in 1969. A list of widely held conclusions, based on Spencer's summary and others, might be as follows. They relate to line length and spacing, capitalization, the arrangement of type, and typeface choice:

- Line length should not exceed 50–70 characters in text at book sizes.
- Keep line spacing open, and greater than the x-height, so that lines are perceived as separate.
- Text set entirely in capitals is considerably less legible than text set in lower case.
- Unjustified setting does not decrease legibility.
- Vertical spacing between items is the most effective way of signalling a separation between two or more elements.
- Typefaces with a larger x-height perform better than those with a small x-height, provided that line spacing is open.
- Relative wideness of letterforms (i.e. generous internal spaces) improves legibility at small sizes.
- Relative blackness of letterforms (i.e. contrast with the background) improves legibility, especially for readers with visual impairment.

Spencer used the word *readability* where we would now use the word *legibility*. Other typographic writers have tried to draw a distinction between the two, notably the type designer Walter Tracy (1914–95). Legibility, according to Tracy, was the quality of letters being decipherable and recognizable, while readability was the quality which allowed the text of a newspaper, magazine, or book to be read for many minutes at a time without strain or difficulty. While this distinction seems to be based in real-world experience—we need to see and decipher a road sign quickly (legible), we want to read the continuous prose of a book page comfortably (readable)—it can also cause confusion. Psychologists agree that what makes type legible is the ease with which we can identify specific letters when they are set together. Our wider ability to engage with the meaning of a document is influenced by many more variables, which are best investigated by understanding the context in which reading is taking place, not just by considering the irreducible facts of perception.

Another reason for avoiding the term readability is that it is used by educational psychologists and others who wish to indicate how difficult a passage is to understand, taking into account sentence length, the use of the passive voice, the number of multisyllable words, and so on. This kind of readability, which does not depend at all on typographic presentation, is measured by statistical analyses that typically calculate 'reading age', the level of education a reader is assumed to need to understand a piece of writing.

How do we read letters and words?

The theory most widespread among designers is that we read whole words by recognizing their overall shape or profile, by matching them to some internal word lexicon, and not by recognizing their individual letters. This is repeatedly stated in textbooks on design, to explain why continuous text set entirely in capitals is less legible than text set in lower case. Although it is true that all-lower-case words have more varied shapes than

all-capital words (which always form rectangles), it does not explain the perceptual processes involved. The counterpart view, that we simply read the letters in words serially, either matching what we see to some internal template of letter shapes or by decoding individual features of a letter one by one, explains certain experimental results but not the totality of results that researchers repeatedly find.

The current theory most widely held by psychologists, and increasingly being understood by designers, is known as Parallel Letter Recognition (PLR), and it best explains the totality of experimental results. In the PLR model, we read by the parallel operation of a bottom-up process, where we identify letter features, and a top-down process, where we identify words. Say we see an r in the word *rose* (Figure 20).

First we recognize individual features. We don't know exactly what these are, but we can suppose they might be a vertical (as opposed to a horizontal) line, and a curved (as opposed to a straight) line. This information is passed up to the letter detection level where, for example, the letter detectors for r, n, and u would be activated, because those letters combine vertical and curved lines. As they are recognized, these potential letters are passed to a word detection

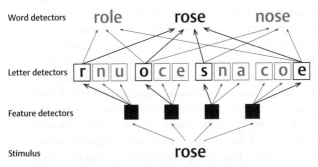

Word detectors role rose nose

Letter detectors r n u o c e s n a c o e

Feature detectors

Stimulus rose

20. The Parallel Letter Recognition model (after Beier).

layer, which works downward with matches for likely words in the word lexicon (*rose* from the group *role, rose, nose*) that the offered combination of letters suggests. The model, which fits the experimental data, asserts that we read by recognizing letters, and not word shapes. We first see and process individual features into letters, and, as we are identifying the letters, in parallel we process these groups of letters into words by lexical matching. When we read a word that is not in our internal lexicon, we have to spell out the word, using serial letter recognition. Building on this, psychologists suggest a combination of three mental processes in reading: letter, word, and sentence-context recognition. The sentence-context recognition process is what allows us to confirm that it is indeed *rose* we are reading, and not *role* or *nose*, when the context is *lovely as a ----*. By reminding us of the significance of both letter and word recognition, and the importance of context, this model helps us see how all aspects of a piece of typography— from individual letters to words to supporting context—assist the reader in efficient reading.

PLR treats letters as combinations of basic shapes. But different typefaces present these component shapes (vertical and horizontal lines, curves, and so on) differently. How does this affect the reading process? How do we see 'through' a character presented in a particular typeface to the underlying form of the letter? Type designers work with several overlapping objectives. They want individual letters to be differentiated, but the overall appearance of the typeface to be harmonious: type designer John Hudson calls this a 'core problem' for type design. The psychologist Peter Walker has described the aspect of a typeface that codifies the underlying forms into specific shapes as 'a set of rules for translating the prototypical structural features of every letter of the alphabet into a printed surface form'. Work done in the 1980s by researcher Thomas Sanocki indicates that we 'tune in' to these rules when reading a particular typeface, developing familiarity over time. He demonstrated this by showing that mixing characters from different typefaces slowed down reading. Perhaps there is

a convergence here between what psychologists are explaining about the reading process and what craft knowledge in type design has striven for over time: stable alphabets that offer the reader certainty, and which they can become accustomed to reading. In this respect, the widely reproduced comment by the type designer Zuzana Licko from 1990, 'typefaces are not intrinsically legible . . . readers read best what they read most', contains both a misconception (some letter shapes *are* less easily recognized) and a truth (readers tune in to typefaces).

Where might the findings of investigators converge with practitioner knowledge? In 2013, the psychologist Mary Dyson noted convergence in designers' views on character spacing and research into the phenomenon known to psychologists as crowding, where the recognizability of a letter is compromised by the close proximity of others. She reported studies showing that crowding reduces reading speeds when text is set with less than normal letter spacing, but that for most readers there is no evidence that increasing spacing beyond what typographers regard as normal reduces the effect. (Other researchers note that one class of dyslexic readers has greater problems with crowding, and for them increased letter, word, and line spacing will help.)

Dyson also points out that psychologists and designers can draw different conclusions from the same effect. She points to views on the way we perceive word shapes. Designers, as noted, often mistakenly believe that we read word shapes rather than individual letters; perhaps this is influenced by their knowledge that the visually correct side-by-side placement of letters is important in both type design and typography generally. What designers are concerned about is the identifiability of individual letters when seen in combination. Here they may not be so far from psychologists who try to identify the more noticeable features of letters—although there is disagreement about whether these features are the mid-segments, stroke junctions, or stroke terminals. If the characteristic parts (the spur of G, the tail

of R) that enable letter recognition are clear, then those clearly distinguishable letters will make clear words. The position of these distinctive features has consequences: in English, there are more letters with unique shapes above the midline than below. This can be effectively demonstrated by setting a line of type with the lower half of the letters obscured: the words remain legible.

Internal patterns within letters are important too. Many letters share internal features and they need to be kept distinct, especially when text matter is degraded by repetitive reproduction (such as faxing or photocopying) or when letters on signs suffer from light halation when they are viewed at a distance.

Experimental methods

Different methodologies may be appropriate for different kinds of investigation. Miles Tinker (1893–1977), an American psychologist, exposed the same typefaces to different test methods, revealing large differences in performance. This finding confirmed the view of practitioners that the legibility of a typeface is not a universal, where one feature or set of features performs well under all circumstances. It is therefore vital to decide which aspect of reading we are concerned with before we begin experimentation.

For continuous reading, there is a choice for investigators to make between oral and silent reading, and between comprehension and a search task. When considering legibility, methods to determine the reader's visual accuracy threshold include briefly exposing the subject to a stimulus, which can establish the subject's ability to identify letters, or varying the height of the target letters and their distance from the subject's eye, which is appropriate when testing material to be read at a distance. Lastly, readers may be asked if they have a preference for one example over another. While this last technique may tell us something about what readers *think* is legible or easy to read, or about their general typographic preferences, typefaces which score highly for reader

preference may perform poorly on other measurable criteria. Perhaps readers, while able to derive sophisticated information from typography, are less able to articulate exactly what works for them. Familiarity and acceptability in the presentation of reading matter are important (this is discussed in relation to non-Latin typography in Chapter 8), but aspects of legibility can be measured, and solutions to specific problems can thereby be developed to enhance reading.

The first thing to recognize is that questions about how to optimize typography cannot ultimately be resolved out of context. Some research can point to underlying constants of visual processing, but it is too easy to ask questions that are simply conundrums. To typographers, asking 'is a sans serif type better or worse than a serifed type?' is simply the wrong question: most will respond 'it all depends'; even researchers testing typefaces with low-vision readers cannot offer a completely generalizable answer. Sans serif and serifed classes of types, despite their nomenclature, differ in a number of ways beyond the presence or absence of serifs. The terms are descriptions, not prescriptions.

Sans serifs typically have a very low stroke contrast (difference between thick and thin strokes) whereas serifed types typically have greater contrast. Sans serif x-heights are typically larger than those of serifed types. But within both classes we see enormous variety: sans serif designs range from the very light to the very dark, and serifed designs can vary in contrast ratio from low to very high. Both classes can vary in the degree of aperture (the openness of characters such as a, e, or s). This makes size-for-size comparisons difficult, and, even when x-heights are equalized (Figure 19, p. 106), may make it difficult to present two lines of text of the same width that contain the same number of characters.

Within the sans serif class, we can distinguish three distinct styles (although there are many designs that are hybrids). The first is called grotesque, from the description that was used by

nineteenth-century type founders. In this style, exemplified by Helvetica and Arial, letterforms are mechanical and have small apertures. Geometrical sans serifs such as Century Gothic are based on the circle and the square, while humanistic designs such as Fresco Sans have more open apertures, and are more freely drawn, often with features reminiscent of pen strokes. In several respects, humanistic sans serif letterforms are the closest to serifed letterforms.

One way of analysing the differences between serifed and sans serif typefaces is to consider the aspects in which they are consistently heterogeneous (displaying visual variety) and those where they are homogeneous (tending to visual uniformity). Whether they are 'old face' or 'modern' (see Chapter 2), serifed designs show much more homogeneity in the rhythm of their vertical strokes than sans serifs, and more heterogeneity in character widths and shapes. Serifs allow letters with vertical strokes to be positioned at almost the same frequency as the near-vertical components of rounded letters such as d, e, and o, despite the latter group's different widths. (Serifed a and s are almost always narrower than c and o, whereas these characters are often the same width in sans serifs; the left and right serifs on characters are often different.)

Conversely, many sans serifs tend to show a more irregular rhythm of vertical strokes and much more homogeneity in character shapes than serifed typefaces. This is most clearly seen in grotesque and geometrical sans serifs. In a typeface such as Helvetica, not only are a and s as wide as c and o, but, without serifs, the bowl and stroke components of the letters b, d, p, and q can be much more similar. In geometrical sans serifs, these letters may even share a single shape transformed by reflection and rotation. Humanistic sans serifs have a rhythm of vertical stokes that is much closer to the regularity of serifed typefaces, and a and s are narrower than c and o. In these designs, the letters b, d, p, and q are related in the same way that they are in serifed typefaces.

The question of the relative legibility of serifed and sans serif typefaces comes up over and over again. The type designer Gerard Unger, writing in 2007, described how disgruntled responses from its readership caused the Dutch newspaper *Trouw* to jettison all-sans typography in 1998 after twelve years and return to setting its body text in a serifed typeface. *Trouw* had been unusual among newspapers in adopting a sans serif for text, and it may be that the reader response was more to do with this difference from the genre norm than because they found the text difficult to read. Unger himself suggests that the objection was more emotional and aesthetic: he argues that it was not a case of measurable legibility, but that somehow *Trouw* looked better in the serif text, as the serifs 'seem to make words and lines hang together better'. This explanation, however, is not supported by the evidence, according to Dyson:

> There is no evidence that serifs have the functions of keeping letters together or words in lines. These are two quite distinct functions and neither fits with what we know about reading. It is possible that the explanation stems, in part, from the mistaken belief that we use word shape, rather than individual letters, to recognize words.

So we need to investigate legibility in context: what may be a desirable aim if we are reading continuous prose may not help us choose a typeface for a road sign or for use in very small sizes on a digital interface: in both these cases salience is paramount. Nor may it accommodate the particular experience of the visually impaired. The following paragraphs relate some recent research focused on typeface design, showing the range of experimental approaches and the kinds of contexts that have been investigated recently.

Optimizing type design

In 2012 the researcher Ann Bessemans worked with a range of visually impaired children who were beginning readers.

(The context is important: there are many different kinds of visual impairment, and these different conditions, at different ages, give rise to different kinds of reading difficulty). The study focused on heterogeneous and homogeneous features in type. Bessemans recounts that readers with normal vision read a normal serifed type with a homogeneous rhythm with fewer errors, but this was not the case with visually impaired readers. The normal-vision readers' response fits with type designers' expectations that regularity of rhythm (seen from the earliest times and in scribal precedents) is a desirable feature. But the visually impaired readers responded better to the less-regular rhythms and to the homogeneous shapes of a sans serif. To suit both sets of readers, Bessemans developed a typeface, Matilda, a low-contrast serifed design, and subtly evened out the widths of characters to achieve a rhythm closer to that of a sans serif. This compromise design seeks to assist the visually impaired without being unusual (which would have set the visually impaired readers apart) or detrimental for normal-vision readers. This is an interesting piece of work which has one unusual aspect: while the context was very carefully considered, the investigator and designer of the solution (the typeface Matilda) were one and the same person.

In a more conventional investigation that sought to survey and advise rather than develop a typeface to solve a problem, Sofie Beier, who is both a type designer and researcher into legibility, surveyed information signage practice in 2012. The letters used for signs (and on shopfronts and buildings generally) were traditionally not enlarged typefaces but specially drawn alphabets, designed to be painted or made at large sizes and read at a distance, and also to have some design affinity with the architectural environment in which they were seen. This last concern has, unfortunately, all but disappeared from commercial lettering on buildings, but the development of the information design discipline of wayfinding has created the need for alphabets that can be digitally composed and printed in large formats or laser-cut into three-dimensional letters.

The ability to read information and warning signs at the greatest possible distance is an advantage, increasing safety and reducing stress. Beier identified the important characteristics of alphabets in use from a range of research studies. Some of these features resemble those which are best for type used at very small sizes. Letters need to be robust, so that smaller features are not lost and shapes do not seem to close up or become blurred because of the viewing distance or lighting conditions. While serifs at the tops of letters can assist differentiation, serifed letters are generally liable to 'close up' because of the small distances between foot serifs. Sans serifs are also preferable because they can more easily comply with the other features found to be preferable, large x-heights and large inner counters within letters. Open counters are preferable even when letterforms have to be condensed to fit within a limited horizontal width. However, narrow letters tend to produce more errors in reading than wider characters, indicating that it may be no advantage in such circumstances to have taller characters if they have to be too narrow. Most national highway authorities have regular and narrow alphabets for road signs: the UK only uses a single, wide alphabet with open counters. The UK alphabets also conform to Beier's advice that letters should be widely spaced, and that a lighter weight is used when white letters appear on a dark ground, and vice versa. This counters the effect of white letterforms appearing to bleed into the darker surface. Letters that are too closely spaced can appear to merge because of crowding or 'contour interaction', where neighbouring letters within a word interfere with each other.

Collaboration and iteration in type design

How can psychologists and type designers collaborate in the creation of new designs? The typeface Sitka (2013) was developed by Microsoft to render text in the Windows 8.1 operating system. The typeface family consists of six optically scaled sets of variants, so that applications can implement the appropriate design size for any kind of text. These were developed in a collaboration between

the design team, led by Matthew Carter, and Microsoft's Advanced Reading Technologies team, led by psychologist Kevin Larson. Specific aspects of the design were tested in studies run quickly so that design iterations could also move forward quickly; this way of integrating investigation rigorously into the design process is still rare.

The various studies, carried out by measuring letter recognition, resulted in data that helped guide the design team. Decisions made as a result included the optimization of the relative proportions of lower-case letters, of the degree of aperture, and of the shapes of letter terminals. It was found that letter recognition in the first design, with a large x-height and reduced descenders and ascenders, was lowest for letters with descenders: the design was revised, lengthening descenders and reducing the x-height and ascenders. This improved letter recognition for all letters, not just those with descenders. The optimal aperture for characters such as a, c, e, and 3 seems to differ when the characters are part of a word (when open apertures are better for recognition) from when they are presented alone (when more closed apertures are better). Because all the fonts were intended for continuous reading, it was decided to use a more open aperture. The shape of letter terminals was similarly determined, so that the shape that performed best across the majority (except the letter a) was adopted throughout for design consistency.

Larson and Carter made a set of pragmatic decisions when conflicts emerged between the preferences stated by readers and reader performance in experiments. This occurred in the Greek character set: a version of the typeface with a smaller x-height was better for the recognition of Greek accented letters. This solution was rejected, however, because it would have reduced the degree of harmony between Greek with Latin characters. The style of Greek accents that gave better letter recognition was rejected, because it was not considered normal enough to be acceptable to Greek readers. Finally, the studies seem to demonstrate that optical

scaling (see Chapter 2) is an essentially aesthetic solution, rather than a feature that improves fundamental letter recognition at all sizes: the wider, more open, darker letterforms of the smallest design size performed best at both small and large sizes. This may explain why type designed for use at small sizes in print and alphabets designed for use at large sizes on signs share similar characteristics. In the context of a printed or web page, which presents the reader with a hierarchy of different type sizes, optical scaling looks good and can assist space-economy; on a road sign, where the reader sees no other sizes of letters for comparison, a clear, bold, open alphabet works best.

Identifying user needs

Psychologists and designers can also work together effectively in the design of documents, particularly in areas such as health care and finance, where forms (which are often still printed) are a key part of communicating with patients or clients. The design of such forms inevitably involves trade-offs between clarity for the client or form-filler, the amount of data that is required to be collected, and physical constraints such as paper size. Drawing on approaches such as situated action, psychologists are able to design methods to best evaluate user needs in these circumstances. Situated action, which stems from human–computer interaction research, reminds us that people's behaviour is contextualized, and that it is difficult to generalize and predict behaviour from one situation to the next. Observing how users interact with specific documents, in a natural environment, is an important tool in developing effective designs. This approach can yield more informative results than simply asking users what they think, or relying on the assumptions of the organizations with whom the users are interacting. And of course the design of such documents is inextricably bound up with decisions about the kind of language that should be used to maximize understanding, as we saw in Chapter 3.

Accessibility and user interaction with design

There is growing awareness (now supported by legislation) that we must be inclusive in our communications, and not exclude those who encounter difficulty with reading. If we are to be inclusive in our designing, we need to take into account the difficulties encountered by a large ageing population and those who are dyslexic, as well as those with any kind of visual impairment. A problem arises when legibility research is used, not in the development of specific designs, as in the examples we have seen, but as catch-all guidelines.

Disability discrimination legislation (in the UK, the Equality Act 2010) placed a responsibility on designers to design inclusively, and various guidelines such as those of the UK Association for Accessible Formats propose minimum standards for clear print, to be used whenever organizations communicate with the public. Their overall guidance is sound, and in line with the studies we have seen in this chapter. Typically they advise people preparing documents (who may not be professional designers) to establish the reader's needs, to use plain typefaces, and to avoid light or coloured text.

For very straightforward documents this advice is uncontroversial. But these and other guidelines have been criticized by Robert Waller and others because the minimum text size they recommend—between 12 and 14 pt—can make documents unwieldy, especially when the document is complex, and the text contains notes, lists, tables, and diagrams. The advocacy of larger, bolder type for body text means that the use of carefully graded type weights and sizes to indicate hierarchical relationships becomes more difficult to achieve. Critics have pointed out that documents that adhere scrupulously to the guidelines lose visual articulation through typography. Paradoxically, this may make them less easy to read, and may compromise their use by other readers.

Another criticism is that such guidelines seem to focus, not on the full range of possibilities open to professional typographic design, but on the much more limited options that were typically available to the users of word processing applications, but without explicitly stating this. As a result, advice on typeface choice not surprisingly focuses on typefaces previously widespread in applications such as Microsoft Word. While Georgia and Arial may have been appropriate choices on desktop PCs in the late 1990s, the development of new designs for print and on-screen use, the rise of web fonts, and much higher screen resolutions, has rendered some of this advice obsolescent.

Perhaps the biggest change in reading habits since the development of the personal computer has been the growing expectation that readers can interact with the presentation of electronic text and, in the case of mobile devices, choose the screen orientation, thereby changing the line length. Most significantly, this interaction relates to type size: older readers or those with visual impairments have found the ability to increase the size of type on electronic documents a boon. (Anecdotally, this is why Prince Philip likes reading books on his Kindle.) Dyslexic and other users benefit from being able to change the contrast ratio of text to background, or to change the text or background colour. These are real gains, which should be seen positively by designers. Users are not 'messing with their designs', but negotiating the best reading solution for themselves: designs for reading on screen need to be responsive. This is why typographers need to have a clear understanding of which factors help the majority of readers, and which cater for specific visual conditions. Design for accessibility is a difficult area to navigate. This points even more strongly to the need for typographers to really understand their readers as well as the technologies they use to read. In this way they will be able to critically evaluate any new research or guidelines, and be able to plan documents for a multiplicity of needs in a multimedia environment.

Mrs Dalloway said she would buy the flowers herself

Mrs Dalloway said she would buy the flowers

Mrs Dalloway said she would buy the flowers herself

Mrs Dalloway said she would buy the flowers

Mrs Dalloway said she would buy the flowers herself

Mrs Dalloway said she would buy the flowers

21. Different approaches to historical influences in creating digital type, all shown at 30 pt: (*from top*) Founders Caslon, an accurate digitization of a historical original; Adobe Caslon, a regularized version of the same original; Arno Display, a reinterpretation of the fifteenth-century type shown in Figure 5 (p. 9); Miller Display, a reinterpretation of a nineteenth-century 'modern' type; Arnhem Fine, classical in proportion but not based on a specific historical precedent; Tisa, a design that appears to have no single direct influence from the past.

Chapter 8
Positive typography

Typographic primers typically begin or conclude with a list of rules, or a statement of typographic canons or standards. While there is room for such a normative approach (and this book includes Appendices of advice to beginning typographers), the author's preference is for a positive, rather than rule-bound, approach: what should we keep in mind while designing, and what are the benefits of designing in a multimedia, global era?

The designer listens to, and acts for, the reader

In a typographic play on the Danish film-makers' *Dogme 95* rules, which set out rules for 'purity' in film-making, the designer and academic Paul Stiff (1949–2011) proposed a set of rules for typographic designers (see Appendix 1). The first 'dogma' was 'Readers come first, second, and third'. Designers have to separate themselves as readers from the potential readers of their work. This may not be easy. Designers find it easy to design for other designers and to allude to, or expect others to recognize, the design idioms they choose to work in. One answer is to embody a research-led approach into design practice, so that each design decision has a rational basis, one that is not simply based on personal preference. Designers do this by following processes such as 'discover, transform, make', to ensure that, on receipt of a client brief, there is an initial phase of questioning and testing

the validity of the brief. Only after confirming and restating the brief to the client, and researching users' needs, can the designer move on to consider how the material to be designed can be transformed, first into a concept, and then into a practical, realizable form that takes account of production and delivery systems. It is essential to recognize that design is always a team activity: someone upstream of the designer will have created the text, and someone else may have edited or modified it. There are always colleagues downstream as well, to whom any design work is passed: production managers, coders, printers, sign makers, each with specific technical knowledge the designer can draw on.

Complex production processes always take on a life and dynamic of their own—in publishing, for example, the cycle of commissioning, editing, physical production, and marketing can lead to design problems being seen as determined by, and only soluble through, the established division of labour. If designers are seen as having responsibility only for the look of the text and cover of a book, the system may make it difficult for them to influence (or even know) the choice of paper or binding glue. But decisions made about these materials will fundamentally affect the book's ease of handling and opening. If the glue is too tight, the first design response that a reader has to such a book (after they notice the cover) may be that it fails to stay open and that the edges of the text closest to the spine cannot be read easily. This response will colour or negate any further engagement with other design features of the book.

Solving such problems requires either a broader role for the text designer (which may not be practicable within a workflow) or, perhaps more properly, recognition that responsibility for design is indeed a team responsibility, and that the communication of design priorities within a team should be better understood. Often it is the designer who has to bring the reader's needs or responses into play, when others are concentrating on getting the thing made and published, because typographic designers

have a particular interest in the quality of the objects they design. In the early days of designing for the World Wide Web, when the division between typographic designers and coders was at its greatest, poor implementation of design concepts and illegible solutions were widespread. The increasing computer literacy of designers and design literacy of software engineers has changed that. These changes were made possible by the adoption of international standards, the commonality of tools available to software engineers and designers, and the incorporation of explicit typographic features in markup languages such as HTML5. With these advances, designers regained the means of implementing effective design, when previously they had to specify at arm's length.

Research is the basis for practice (history helps)

The research into legibility and user needs and behaviour described in Chapter 7 can provide the underpinning for good decisions in contemporary practice. Understanding such research helps us look at historical and present-day examples of typography that have been recognized as 'good' in a new light. Are the icons of the past really sustainable as models for new design? If so, is it because they adhere to testable, repeatable principles of functionality for users, or is it because they have achieved some cultural visual significance? If designers can develop critical approaches to the work of others, there is some chance that they can apply those same critical approaches to their own work.

Because most typographic challenges sit firmly within specific genres (see Chapter 4), attempts to formulate universal rules for good typographic practice based on past research may result in generalizations. The needs of a particular genre force us to consider the applicability of any general research, and to focus on a relevant subset of the research findings. (A newspaper designer will not be concerned with research into the best method for cueing footnotes, for example, but will be interested

in studies that track the eye movements of readers across their pages.) Researchers develop specific methodologies to address particular situations—as we have seen, the most generalized questions (serifed or sans serif? ragged or justified?) produce the vaguest answers, while specific questions (which x-height suits both the Latin and Greek scripts best?) produce the most specific—if not always easily applicable—answers. And in any new printed document, online text delivery system, or environmental information context, there may be new needs driven by new audiences or new content.

To cope with the unceasing novelty of these demands on them, designers need to internalize a research mindset, so that while the adoption of tried and tested genres is second nature to them, so is a questioning approach. Designers need to question whether the client brief is complete, whether the copy is final or liable to change, whether the readership has been defined or understood (or asked its opinion) thoroughly enough to confirm how that genre should be adopted, adapted, or ultimately rejected. In Chapter 5 we met the concept of the transformer, a role combining research, visualization, and specification for information design that practitioners should aspire to. Doing so allows designers to move from cookie-cutter designing, where a style is applied to a product simply on the basis of a superficial description of its function, to genuinely engaging with the content, the delivery method, the production process, and the reader.

History helps us—if we question it. The London Underground diagram by Henry C. Beck (1902–74) is not a design icon just because of its formal visual qualities, or because it adorns mugs and tea towels, and is parodied by artists. It is an icon because it has all the attributes of good typography and good information design: it is usable, understandable, adaptable; its visual scheme is modular, built on geometry but not forced into geometric formalism; it uses a coding system (colour) which plugs it in to other documents and signs; it uses a consistent treatment of words

and symbols, so that these elements are mutually reinforcing; it is also practical and scalable to viewing from different distances. Significantly, Beck himself never ceased revising and developing the diagram: Ken Garland's 1994 history of the diagram shows many iterations from his hand alone from 1933 to the 1960s. Not being satisfied with the first solution, however successful, is the hallmark of a designer. Understanding excellent designs from the past in such analytical terms, rather than simply regarding them as graphic images to fetishize, is the challenge—when we do it, we can learn from the past.

Can we revive the past?

Chapters 1 and 2 rapidly surveyed the history of typographic letterforms, and discussed particular historical typefaces. In one sense the whole of typographic history is now available to us, both as a serious resource for design ideas and, more playfully, as a dressing-up box. When designing a book, we might decide to use Caslon because it is an eighteenth-century English literary text (a decision based on associative historicism). We might choose Caslon because the rhythm, spacing, and weight of that typeface are just right for the page. Or we might choose to set a punk musician's memoirs in Caslon because we see echoes of the instability of language in the discord between their strident, iconoclastic words and what we perceive as the calm, old-fashioned air of the typeface.

We might elevate these three approaches to cultural positions by describing the first as that of a 'new traditionalist' (for whom continuity and association with historical styles are important), the second as that of a pragmatist (it just works!), and the third as that of a postmodernist (because it neatly points out a discrepancy between the garb of language and its content). But if we choose the first and third options we must remember one thing. The digital type available to us today that bears the name is not, in truth, Caslon. The whole visual quality of Caslon is tied up with

the physical qualities of hand-made punches, hand-cast type, hand composition and letterpress printing—the slight irregularities of casting and inking, the kind of ink, the kind of paper, and the impression of type into that paper. True, composition machine manufacturers made remarkably accurate versions of Caslon, but these still lived in the world of cast type and letterpress printing. Should we regard physical and photographic or digital type as quite separate media, the first kind material, the second kind immaterial? And if so, is it possible for particular designs to be truthfully translated from one medium to another?

The exact shape of eighteenth-century Caslon types could be successfully transferred to twentieth-century mechanical composition machines (both original type and new machinery being firmly in the material world) and produce a reasonable facsimile in print because those composition machines created type that underwent exactly the same physical processes of casting and being printed from as the originals. No such physical mapping of process exists today with digital type, which, even for printed materials, is rendered with laser accuracy on a printing surface and transferred with remarkable fidelity to the receiving substrate. Today's printing processes have done away with almost all of the irregularity and image distortion that was part and parcel of letterpress printing of the past.

Two versions of Caslon, created on opposing principles, pertinently raise the question of how we can or should use typographic history when designing today (Figure 21, p. 124). Adobe Caslon (1990), created as a digital typeface by Carol Twombly, is a highly regularized design; a single master suffices for all sizes. While it is clearly based on text sizes of Caslon, its designer has ensured that Adobe Caslon can be set much larger than 12 pt and still look elegant. Of course, as it is used at increasingly larger sizes, Adobe Caslon looks less and less like its metal namesake, where every size was cut separately, and where individual characters change shape, sometimes dramatically, from size to size. Founders Caslon

(1998), scanned and digitized by Justin Howes (1963–2005), aims to capture faithfully the impressions of individual pieces of type at specific sizes: it is intended that the 12 pt version is used for setting at 12 pt, the 18 pt version at 18 pt, and so on. It can be used to make superficially accurate facsimiles of matter printed in metal Caslon—although the degree of irregularity and ink squash that the designer has built into the characters can only be one instantiation of the many possible printed results that can be obtained from metal type printed with many combinations of press and paper.

Adobe Caslon can either be considered as historical revival, and be selected for that reason, or simply as a practical text typeface with particular characteristics. It doesn't quite fit the obsessive associative historicist's criteria because its single master size means that it only really resembles Caslon's original in the 10–12 pt range. But for the rest of us pragmatists it is a perfectly usable typeface, one (an elegant one) among many. Founders Caslon is a tour de force, and a salutary reminder of exactly how varied the original metal family of types was. But it is difficult to use outside a determinedly historical context—when creating a facsimile of a piece of period printing, or for the frisson of 'postmodern' inappropriateness alluded to earlier. No wonder the critic Robin Kinross suggested that 'Visually speaking, perhaps the most important question that emerges from the process of translating typefaces from one system to the next is: what is the right version of the typeface?' And perhaps we also have to ask, why a digital Caslon at all? We have to accept that historical names have pulling power when marketing typefaces, and it is clear that historical types *do* have visual qualities, whether these are inherent in their physicality or not, that are worth reviving. Does each generation of technology that moves us further from metal type and letterpress require us to forget the past and simply create new designs? This was certainly the view of the Dutch designer Jan van Krimpen (1892–1958) who, even though he created designs for metal type, worked only with immense reluctance on type revivals, preferring

to develop his own distinctly twentieth-century designs. While
Van Krimpen worked firmly in the tradition of type for books,
some fifty years later designers such as Zuzana Licko and Jonathan
Barnbrook looked at historical typefaces not to revive them,
but to reinterpret them radically as digital type for new kinds of
publications.

In 1990, commenting on the availability of digital fonts on
personal computers, the magazine designer Roger Black predicted
that in '2000 everyone will have a favourite typeface'. The type
design industry has expanded enormously since then. Compared
to the mechanical composition era, typefaces can be created today
far more easily and cheaply. There is a widespread, global base of
skilled typeface designers, often trained on specialist university
courses in the UK, USA, and Europe, that would have been
unimaginable fifty years ago. Many of the new designs that this
cohort produces are historically informed, but not slavish copies of
previous types. While phototypesetting did not inherently reduce
typographic quality, the short cuts that it offered were typically
employed to reduce costs at a time when text composition, still
a capital- and labour-intensive operation, was increasingly under
financial pressure. As a result, size-specific masters and variants
such as old-style figures and true small capitals and superiors,
although created by manufacturers, were often jettisoned as too
costly by printers in the 1960s, 1970s, and 1980s. These features
were gradually restored as digital font technology developed,
culminating with the OpenType format, which made them easily
accessible at very low cost.

Digital type foundries have reissued many classic designs in
reworked versions—for example, in 2015 the Gill Sans series
was reborn as Gill Sans Nova. While this obviously has an
aspect of marketing expediency—how otherwise can a foundry
exploit its backlist and achieve new sales?—the reworked
series are almost always better adapted to current production
conditions. They may incorporate non-Latin scripts and

support more languages, add alternative figures and contextual alternatives, or, by adjusting character weights, correct poor decisions made when metal designs were originally transferred to photocomposition. A few years ago true *ITALIC SMALL CAPS* were a rarity in serifed typefaces—now they are becoming common in sans serif typefaces too. Minute weight variants of a design (known as grades) can ensure that a publication such as a newspaper can achieve a consistent visual appearance when it is printed at different plants whose presses have different inking characteristics. Most importantly, new typefaces are created to be suitable for readers of all kinds of digital media, not just of print. These designs are underpinned by a common Unicode standard that ensures the correct rendering of almost any language's characters whether on a computer, a mobile device, or digital displays in public spaces.

Good typography = global typography

In Chapter 2 we saw how the storage of large numbers of type designs, each containing large numbers of characters, had become trivial since the development of digital fonts. The development of the Unicode standard (1988–; currently Version 10, 2017) and the OpenType format has allowed the integration of characters from different global script systems in an unprecedented way. Historically, setting non-Latin text (Greek, Arabic, Hebrew, Chinese, and so on) in conjunction with Latin was problematic. Non-Latin scripts required different, often large, character sets. The incompatible proportions of characters in different scripts and the inflexibility of metal type made combining sizes difficult. Combining the Latin script, which reads from left to right, with those that read from right to left (Arabic, Hebrew), or from top to bottom (Chinese, Japanese) required special composition systems. In the West, there was limited availability of type designs for non-Latin scripts. The transition from this state of affairs to the current position, where we expect online documents to be rendered perfectly in any one (or any combination) of over 130 writing

systems supported by Unicode, is unprecedented, and a genuine cultural achievement of digital technology.

Questions arise about the appropriate form of type designs for scripts which have moved directly from a culture of handwriting to a digital culture in more or less one move. Latin typography, as we have seen, has a long history of design experimentation and development: the handwritten basis of our letters is still there, but it is overlaid by centuries of regularization and modularization that we take entirely for granted in typographic matter. Only a limited range of designs in non-Latin scripts was available in metal type. These scripts, having suffered excessive regularization from previous print technologies, are finally able to return to the subtleties and complexities of their handwritten past thanks to current technologies. This is certainly the case with many Indian scripts, where changes made in quite arbitrary ways by Western type founders (often for quite understandable technical reasons) have been redressed in new designs. For Arabic, the removal of mechanical constraints means that initial, medial, terminal, and stand-alone characters and ligatures can each be represented faithfully, rather than by various compromise forms that were used throughout the period of mechanical typesetting. The downward slope of words characteristic of the best traditional calligraphy, and the correct positioning of vocalization marks, can now be achieved. The typeface Nassim (2010), designed for the BBC Arabic website by Titus Nemeth, includes regional variants so that North African, Arabian, and Asian Arabic texts can look familiar to their readers.

The coexistence of different scripts on the page or screen raises other questions, often under the umbrella of 'harmonization'. Ignoring typographic parodies, which try to give Latin words the flavour of Russian by flipping the letter R to resemble a Cyrillic Я, or to mimic Hindi by hanging characters from a headline, there are a range of approaches to harmonization. At one extreme, harmonization means the adoption by the non-Latin script of Latin norms of stroke weight, angle of stress, and relative

proportions. Done deliberately and conscientiously (an example is Helvetica Greek, 1971, designed by Matthew Carter), this can provide a genuine match in style, weight, and alignment with the equivalent Latin typeface. Done rather less well, the Latinized script is not only damaged culturally, but the changes are detrimental to legibility, because they depart from readers' expectations. Writing in 2016, Titus Nemeth cited as an example the Arabic used alongside Latin on airport signs at Abu Dhabi. In an effort to make the proportions of the scripts match, elements below the baseline, which are more important in Arabic than in Latin, were reduced to match the shorter Latin descender depth, while those above the baseline were uncharacteristically enlarged to match the Latin x-height, producing a design with quite inappropriate proportions. An equivalent distortion of Latin letters in such a situation would be seen by Western eyes as bizarre.

At the other end of the spectrum is the development of type designs which stay close to the cultural origins of their scripts, but which can be combined technically and aesthetically with typefaces in other scripts. In some ways this is a return to the approach taken by the printers of polyglot books in the early modern period: harmonization then was on a technical basis, so that the types would fit and print well together, rather than forcing designs away from their stylistic or script-based differences. These new designs do not take components of Latin letterforms and rearrange them; rather they take their cues for proportions and design details from both historical references of the script in question and from the particular technologies which will be used to render them. Examples are the Nirmala UI Devanagari typeface for Microsoft's Windows interface (2011) and the Indian script designs developed for printing parallel texts in the Murty Classical Library of India (2015–) under the art direction of Fiona Ross. This shift to a more holistic view of harmonization between scripts is reflected in the shift in attitude among type manufacturers and typographers from thinking about 'non-Latins' to 'world scripts'.

Typography today

The technologies for presenting graphic language have never been static. The long dominance of one set of technologies, metal type and letterpress, masked important shifts in how, across the centuries, printing was transformed from the production of books for an elite few to be at the service of a newly literate mass public in a myriad of ways. Early typography did indeed focus on books, but the print culture of the seventeenth, eighteenth, and nineteenth centuries developed new forms such as the newspaper and magazine, then the advertising flyer and poster, the banknote and cheque, the tourist guide and printed map, the commercial catalogue, and the official form. Each of these new kinds of printing, requiring new design approaches, sprang from the requirements of society and commerce, from new possibilities and opportunities for readers to read in new ways.

The transfer of much of our reading today from paper to screen has echoed these earlier developments, but has occurred at a much faster rate. The more advanced the technology, the more fragile it can become. It is an irony that the technologies familiar to Gutenberg can still be used by letterpress aficionados who wish to print for pleasure, while the technologies of phototypesetting, so prevalent a few decades ago, are now all but irretrievable. Printing by letterpress for pleasure, to enjoy the effects of inking and the impression of type into paper, may cause us to think of old technologies as quaint, or lacking in the precision and subtlety of contemporary digital publishing. In fact, any acquaintance with typographic history throws up time and time again continuities between the past and present as frequently as it points to ruptures and changes. Books from the sixteenth century display cross-references, annotation, integrated illustrations, and aids to navigating complex text that are equal to those of their electronic equivalents today—and which are perhaps embodied in a more durable format.

Typography's function of organizing our world of incessant information through visual form is as important as it ever was, and fortunately is much more widely taught, understood, and appreciated now that the tools of typographic production and reproduction are in so many hands. The challenge is for the techniques of screen-based typography to advance in areas where print is still fully functional; the challenge for print is to retain its functionality and appeal. Print isn't dead as a way of supporting focused, considered reading, but it is dying as a means of distributing information that needs to be consumed rapidly: the editor-in-chief of the *Washington Post*, Marty Baron, believes that the days of the print newspaper are certainly numbered.

But newspaper typography lives on. Instead of a single print instantiation of the *Post* there are now many, for computers with different screen sizes, for tablets, and for phones, and all of these are available globally, instantly. Each manifestation requires a modulated typographic approach that suits the publication's content to the reader's particular situation, maximizing the efficiency of the device. And yet all these versions have to be bound together by typographic branding and house style to confirm to readers that they are, indeed, holding the *Washington Post* in their hands. Printing moved on from initially reproducing the look of manuscripts to embrace new forms. It is part of the ongoing challenge for typography, as the century develops, to create digital publications that rise above generic or technologically determined approaches to be genuinely at the service of the reader.

Appendix 1
Dogma for typographers

Paul Stiff wrote this inspirational list of dos and don'ts for typographers in 1999. It was written in response to an email circulated by Robin Kinross requesting typographic equivalents for the *Dogme 95* injunctions of Danish film-makers.

1. Readers come first, second, and third. Designing is not done for peer approval or prizes.

2. Readers are neither 'target audiences' nor clichés: they bring their own purposes and questions to every encounter with text.

3. 'Reading' is not one-dimensional: there are many reading acts.

4. Content matters: design nothing that is not worth reading.

5. Stand by meaning.

6. Embrace the big picture.

7. Attend to details.

8. Looking good is better than looking different.

9. Looking good is worthless without making sense.

10. Designing and making is collective work: many brains and hands are involved. The designer must not be credited unless all other workers are also credited.

Appendix 2
Good practice in typesetting

The advice given here is based on typographic practice for print, but applies equally well in the digital sphere.

1. Make sure that the mapping of typography to the structure of the text is consistent and unambiguous.

2. Keep the number of typeface variants (indeed all elements) to a minimum consistent with the hierarchy of the text.

3. When mixing serifed and sans serif designs (e.g. for text and headings), look at similarities and differences in overall structure, x-height, and weight; choose combinations that are sympathetic or wildly different; avoid 'near misses'.

4. Use typefaces with optical variants where possible; use true small capitals, true superiors, and old-style figures in text.

5. More than seventy characters and spaces is too long a line to read! (Very short lines are acceptable in captions and notes.) In justified setting, keep the ratios of the narrowest to the ideal to the maximum word space at about 80:100:120.

6. Make spacing between lines larger as the line length gets longer.

7. Typography is a grid: use modules of size and space that add up so that each dimension looks considered. The type area on page two should align horizontally and vertically with the

type area on page one (it should 'back up'); type in adjacent columns should align horizontally. Intercolumn spaces must be unambiguously wider than the spaces between words.

8. Asymmetric layouts and left alignments can be more flexible than centred ones, which can look unduly formal or forced; in any case only headings should be centred, never text.

9. Larger type can have narrower word spaces than smaller type; for text, generally stick with the default word and character spacing of a font; CAPITALS and SMALL CAPITALS look better with letterspacing (tracking).

10. An em-indent for the first line, and no extra vertical space, is still the best way of signalling a paragraph in continuous text. (The print edition of this book follows an established series style.)

11. Divide words at line ends where necessary according to phonetic principles, e.g. *New Oxford Spelling Dictionary*; consider no word division in ragged setting; consider not dividing capitalized words or those at the end of a paragraph.

12. If you have control over the shape of paragraphs in ragged setting, aim for a fuzzy D shape, so that words at the ends of long lines don't look unsupported; in all setting avoid a very short word on its own on the last line of a paragraph.

13. Consider the reader at the end of columns, pages, and sections: avoid a word division at the bottom of a column, avoid the last line of a paragraph falling at the top of a page, and never allow a heading to become detached from the text that follows it (the number of text lines it must keep with it will relate to its position in the visual hierarchy).

14. When an illustration is mentioned in the text, the reader should ideally be able to see it (and its caption) at the same time, or be directed to it.

15. Consider each page in proof, and if following any of these rules has made the document harder to read, break them!

Further reading

Preface

See Erik Spiekermann, *Rhyme and Reason: A Typographic Novel* (Berlin: Berthold, 1987).

Chapter 1: Perfect letters

For a discussion of letterforms used to teach reading, see Sue Walker, *Book Design for Children's Reading* (London: St Bride Foundation, 2013). On planning and making Roman inscriptions, see Edward M. Catich, *The Origin of the Serif* (Davenport, IA: Catfish Press, 1968). For a general history of letterforms, see Nicolete Gray, *A History of Lettering* (Oxford: Phaidon, 1986); for a synopsis, see Warren Chappell, *A Short History of the Printed Word* (Vancouver: Hartley & Marks, 2nd edn 1999). On variety in Romanesque letterforms, see Gerard Unger, 'Romanesque capitals in inscriptions', in *Typography Papers 9* (London: Hyphen Press, 2013). On the invention of printing and type founding, see Michael Twyman, *The British Library Guide to Printing* (London: British Library, 1998); James Mosley, 'The technologies of print', in Michael Suarez and Henry Woudhuysen (eds), *The Oxford Companion to the Book* (Oxford: Oxford University Press, 2010). For a wider discussion of punch-cutting in type design, see Fred Smeijers, *Counterpunch* (London: Hyphen Press, 1996). On the origins of sans serifs, see James Mosley, *The Nymph and the Grot* (London: Friends of St Bride Printing Library, 1999). On typefaces discussed: Futura, see Petra Eisele, Annette Ludwig, and Isabel Naegele (eds), *Futura* (London: Laurence King, 2017); Gill Sans, see Mark Ovenden, *Johnston and Gill* (London: Lund Humphries, 2016);

Johnston, see Justin Howes, *Johnston's Underground Type* (London: Capital Transport, 2000). On pen strokes in letter design, see Gerrit Noordzij, *The Stroke* (London: Hyphen Press, 2008); Nicolete Gray, *Lettering as Drawing* (London: Oxford University Press, 1971). On Dwiggins, see Bruce Kennett, *W. A. Dwiggins* (San Francisco: Letterform Archive, 2018). For a more critical reading of Noordzij, see Paul Stiff, 'Spaces and differences in typography', in *Typography Papers 4* (Reading: University of Reading, 2000). On Metafont and other type design software, see Richard Southall, *Printer's Type in the Twentieth Century* (London: British Library, 2005).

Chapter 2: Practical letters

On the *roman du roi*, see James Mosley, 'French academicians and modern typography', in *Typography Papers 2* (Reading: University of Reading, 1997). On John Baskerville, see Caroline Archer-Parré and Malcolm Dick (eds), *John Baskerville* (Liverpool: Liverpool University Press, 2018). On the history of type measurements, see Andrew Boag, 'Typographic measurement: a chronology', in *Typography Papers 1* (Reading: University of Reading, 1996). On dictionary typography, see Paul Luna, 'Not just a pretty face: the contribution of typography to lexicography', in Geoffrey Williams and Sandra Vessier (eds), *Proceedings of the Eleventh Euralex International Congress* (Lorient: Université de Bretagne Sud, 2004; at <http://centaur.reading.ac.uk/21116/3/Luna_Euralex_final_Text_Pix.pdf>). On the development of bold typefaces, see Michael Twyman, 'The bold idea', in *Journal of the Printing Historical Society* (22, 1993). For a general history of chromolithography, see Michael Twyman, *A History of Chromolithography* (London: British Library, 2013). On the invention and development of mechanical composition, see Judy Slinn, Sebastian Carter, and Richard Southall, *History of the Monotype Corporation* (London, Printing Historical Society, 2014); Richard Southall, *Printer's Type in the Twentieth Century* (London: British Library, 2005). On the practice of digital type design today, see Cristóbal Henestrosa, Laura Meseguer, and José Scaglione, *How to Create Typefaces* (Madrid, Tipo e, 2017).

Chapter 3: Presenting language

For a different visual consideration of the Shipping Forecast, see Paul Elliman, 'A late evening in the future', in *Dot Dot Dot* (5, 2002).

On configurations of graphic language, see Michael Twyman, 'A schema for the study of graphic language', in Paul Kolers, Merald Wrolstad, and Herman Bouma (eds), *Processing of Visible Language* (Boston, MA: Springer, 1979). On internal vertical justification, see Herbert Spencer, *The Visible Word* (London: Lund Humphries, 2nd edn 1969). On gestalt principles and typography, see Rune Pettersson, 'Gestalt principles', in Alison Black et al. (eds), *Information Design: Research and Practice* (Abingdon: Routledge, 2017). On 'typography without words', see Michael Twyman, 'Typography without words', in *Visible Language* (15(1), 1981). For a discussion from the 1980s of text markup, see James Coombs, Allen Renear, and Steven DeRose, 'Markup systems and the future of scholarly text processing', in *Communications of the ACM* (30(11), 1987; at <http://vision.unipv.it/stm-cim/articoli/p933-coombs.pdf>). On the line-breaking algorithm in TeX, see Donald Knuth, 'Breaking paragraphs into lines', in *Digital Typography* (Stanford, CA: CLSI Publications, 1999). On typographic specification and implementation, see John Morgan, 'An account of the making of *Common Worship*', in *Typography Papers 5* (Reading: University of Reading, 2003); Paul Stiff, 'Instructing the printer', in *Typography Papers 1* (Reading: University of Reading, 1996). For a general discussion of prescription and house style, see Sue Walker, *Typography & Language in Everyday Life* (Abingdon: Routledge, 2000). On language and typography, see David Crystal, *The Cambridge Encyclopedia of the English Language*, especially chapters 20 and 21 (Cambridge: Cambridge University Press, 2003). On styles of language, see Judy Delin, *The Language of Everyday Life* (London: Sage, 2000). The style guides cited are: *New Hart's Rules* (Oxford: Oxford University Press, 2nd edn 2014); *The Chicago Manual of Style* (at <http://www.chicagomanualofstyle.org>); *The Guardian* and *Observer* style guide (at <https://www.theguardian.com/guardian-observer-style-guide-a>).

Chapter 4: Genre and layout

On manuscript production, see Christopher de Hamel, 'The European medieval book'; on the appearance of early printed books, see Cristina Dondi, 'The European printing revolution'; both in Michael Suarez and Henry Woudhuysen (eds), *The Oxford Companion to the Book* (Oxford: Oxford University Press, 2010). On layout in manuscripts, see Daniel Wakelin, *Designing English: Early Literature on the Page* (Oxford: Bodleian Library, 2018). On typographic genres and layout,

see Robert Waller, 'Graphic literacies for a digital age'; on readers' responses to layout, see Jeanne-Louise Moys, 'Visual rhetoric in information design'; both in Alison Black et al. (eds), *Information Design: Research and Practice* (Abingdon: Routledge, 2017). On analysing layout, see Gui Bonsiepe, 'A method of quantifying order in typographic design', in *Journal of Typographic Research* (2(3), 1968); John Bateman, 'Multimodality and genre', in Alison Black et al. (eds), *Information Design: Research and Practice* (Abingdon: Routledge, 2017). On sizing images, see Derek Birdsall, *Notes on Book Design* (New Haven: Yale University Press, 2004). On page breaks, see John Morgan, 'An account of the making of *Common Worship*', in *Typography Papers 5* (Reading: University of Reading, 2003). On Dorling Kindersley page layouts, see Katherine Gillieson, 'Genetics of the "open" text', in *Eye* (57, 2005; at <http://www.eyemagazine.com/feature/article/genetics-of-the-open-text>).

Chapter 5: Picture language

For a discussion of the reliability of graphic presentation of data, see Ian Spence and Howard Wainer, 'William Playfair and the invention of statistical graphs'; on reading symbols, see Alison Black, 'Icons as carriers of information'; on testing symbols, see Theo Boersema and Austin Sorby Adams, 'Does my symbol sign work?'; all in Alison Black et al. (eds), *Information Design: Research and Practice* (Abingdon: Routledge, 2017). For the International Organization for Standardization's online platform, see <https://www.iso.org/obp/ui>. For a wider survey of Isotype, see Christopher Burke, Eric Kindel, and Sue Walker (eds), *Isotype: Design and Contexts 1925–1971* (London: Hyphen Press, 2013). On Isotype as a picture language, see Christopher Burke, 'The linguistic status of Isotype', in *Image and Imaging in Philosophy, Science and the Arts, volume 2*, edited by Richard Heinrich et al. (Frankfurt: Ontos, 2011). On the idea of the transformer, see Marie Neurath and Robin Kinross, *The Transformer* (London: Hyphen Press, 2009). For Tufte's ideas on the presentation of data, see Edward Tufte, *The Visual Display of Quantitative Information* (Cheshire, CT: Graphics Press, 1983). For a discussion of the status of Brinton, Isotype, and Tufte in the history of information design, see Paul Stiff, 'Some documents for a history of information design', in *Information Design Journal + Document Design* (13(3), 2005). The symbol collections cited are: Henry Dreyfuss, *Symbol Sourcebook* (New York: McGraw-Hill, 1972); Rudolf Modley,

Handbook of Pictorial Symbols (New York: Dover, 1976); for the AIGA symbol set, see <https://www.aiga.org/symbol-signs>.

Chapter 6: Emotion or information?

For a survey of Jan Tschichold's work, see Christopher Burke, *Active Literature: Jan Tschichold and the New Typography* (London: Hyphen Press, 2008). For ideas on the relationship of form, function, and aesthetics in design, see Paul Mijksenaar, *Visual Function* (Rotterdam: 010 Publishers, 1997); David Pye, *The Nature of Design* (London: Studio Vista, 1964). On 'transparency' in typography, see Beatrice Warde, *The Crystal Goblet: Sixteen Essays on Typography* (London: Sylvan Press, 1955). On Sutnar, see Steven Heller, 'Ladislav Sutnar's monograph manifesto', in Ladislav Sutnar, *Visual Design in Action* (Zurich: Lars Müller, 2015 reprint of 1961 edn). For a critique of post-war American advertising, see Marshall McLuhan, *The Mechanical Bride* (New York: Vanguard Press, 1951). For the 1964 text of *First Things First*, see Ken Garland, *A Word in Your Eye* (Reading: University of Reading, 1996); for the 1999 text, see <http://www.eyemagazine.com/feature/article/first-things-first-manifesto-2000>. On readers' needs, see Karen Schriver, *Dynamics in Document Design* (New York: John Wiley & Sons, 1977). For notes on the simplification of complex documents, see <http://www.simplificationcentre.org.uk/resources/technical-papers/>. On the rhetoric of information design, see Robin Kinross, 'The rhetoric of neutrality', in *Design Issues* (2 (2), 1985). For views on the origins and development of typographic modernism, see Herbert Spencer, *Pioneers of Modern Typography* (London: Lund Humphries, 1969); Robin Kinross, *Modern Typography* (London: Hyphen Press, 1992). On the Kinross–Keedy debate, see Robin Kinross, *Fellow Readers: Notes on Multiplied Language* (London: Hyphen Press, 1994); Jeffrey Keedy, 'Zombie modernism', in *Emigre* (34, 1995; reprinted with many other useful essays in Steven Heller and Philip B. Meggs, *Texts on Type* (New York: Allworth Press, 2001)). On typographic postmodernism, see Rick Poynor, *No More Rules: Graphic Design and Postmodernism* (London: Laurence King, 2003). On 'design kills writing', see Adriano Pedrosa (design: Michael Worthington), 'Writing and design and the subject', in *Emigre* (35, 1995). For broad historical surveys of typographic design, see Richard Hollis, *Graphic Design: A Concise History* (London: Thames and Hudson, 1994); Friedrich Friedl, Nicolaus Ott, and Bernard Stein, *Typography: When Where How*

(Cologne: Könemann, 1998); on design more generally, see Jonathan Woodham, *Twentieth-Century Design* (Oxford: Oxford University Press, 1997); John Heskett, *Design: A Very Short Introduction* (Oxford: Oxford University Press, 2005). On printed ephemera, see John Lewis, *Printed Ephemera* (London: Faber, 1962); Maurice Rickards, *Encyclopedia of Ephemera* (London: British Library, 2000). On aspects of American vernacular architecture, see Robert Venturi, Denise Scott Brown, and Steven Izenour, *Learning From Las Vegas* (Cambridge, MA: MIT Press, 2nd edn 1997). On Tschichold and Schmoller at Penguin Books, see Phil Baines, *Penguin by Design* (London: Allen Lane, 2005). On Morison, see James Moran, *Stanley Morison: His Typographic Achievement* (London: Lund Humphries, 1971). On Jonathan Barnbrook, see Rick Poynor, 'Reputations: Jon Barnbrook, Virus', in *Eye* (15, 1994; at <http://www.eyemagazine. com/feature/article/reputations-jon-barnbrook-virus>); David Bowie, *Blackstar* (RCA, 2016, vinyl LP; images at <http://www.barnbrook. net/work/david-bowie-blackstar/>); Jonathan Barnbrook, *Barnbrook Bible* (London: Booth-Clibborn Editions, 2007; to compare, see Owen Jones, *The Grammar of Ornament* (London: Studio Editions, 1986 reprint of 1856)). For Weiner's work, see <http://www.tate. org.uk/art/artists/lawrence-weiner-7743>. For Mayer's work, see <http://www.tate.org.uk/art/artists/hansjorg-mayer-17744>. For Alan Kitching, see Alan Kitching and John Walters, *Alan Kitching: A Life in Letterpress* (London: Laurence King, 2017). The artists' books cited are: Ed Atkins, *A Primer for Cadavers* (London: Fitzcarraldo Editions, 2016); Jeremy Deller (design: Fraser Muggeridge), ⬚⬚Ⅼⲅ∩◊ ⊖⊟ ⬚Ꮐ�L△◊⊟ △Ⅼ⬚Ꮐ [*Utopia by Thomas More*] (London: Somerset House, 2016).

Chapter 7: Making typography legible

On early printers' manuals, see Robin Kinross, *Modern Typography* (London, Hyphen Press, 1992). For Morris's critique of printing, see William Morris and Emery Walker, 'Printing', in *Arts and Crafts Essays* (London: Rivington, Percival & Co., 1893; at <https://archive. org/details/printing.essayby00morrrich>). On historical legibility studies, see Herbert Spencer, *The Visible Word* (London: Lund Humphries, 2nd edn 1969); Miles Tinker, *The Legibility of Print* (Ames, IA: Iowa State University Press, 1963). For discussion of legibility and readability, see Walter Tracy, *Letters of Credit* (London: Gordon Fraser, 1986). On Parallel Letter Recognition and research

on signage, and a general discussion of legibility research, see Sofie Beier, *Reading Letters: Designing for Legibility* (Amsterdam: BIS, 2012). On what 'readers read best', see Zuzana Licko, 'Do you read me?', in *Emigre* (15, 1990). On differences between psychologists and typographers, see Mary Dyson, 'Where theory meets practice: a critical comparison of research into identifying letters and craft knowledge of type design', in *The Design Journal* (16 (3), 2013). For recent legibility research, see Ann Bessemans, 'Matilda: a typeface for children with low vision'; Kevin Larson and Matthew Carter, 'Sitka: a collaboration between type design and science'; both in Mary Dyson and Ching Y. Suen (eds), *Digital Fonts and Reading* (Singapore: World Scientific, 2016). On traditional lettering on buildings, see Alan Bartram, *Lettering in Architecture* (London: Lund Humphries, 1975). On 'clear print' guidelines, see UKAAF, 'Creating clear print and large print documents' (2012; at <https://www.rnib.org.uk/sites/default/files/UKAAF%20creating%20clear%20print%20and%20large%20print%20documents.pdf>). For a critique of such guidelines, see Robert Waller, 'The Clear Print standard: arguments for a flexible approach' (2011; at <http://www.robwaller.org/SC10ClearPrint_v5.pdf>).

Chapter 8: Positive typography

On the London Underground diagram, see Ken Garland, *Mr Beck's Underground Map* (London: Capital Transport, 1994). For a wider discussion of designers imitating earlier designs, see Tibor Kalman, J. Abbott Miller, and Karrie Jacobs, 'Good history/bad history', in *Print* (45 (2), 1991; at <http://wwwcdn.printmag.com/wp-content/uploads/GoodHistoryBadHistory.pdf>). For a definition of 'new traditionalism', see Jan Tschichold, 'The New Typography', in *Circle* (1937; quoted in Paul Rand, *From Lascaux to Brooklyn* (New Haven, CT: Yale University Press, 1996)). On reviving historical typefaces, see Philip B. Meggs and Roy McKelvey, *Revival of the Fittest* (New York: RC Publications, 2000); Paul Shaw, *Revival Type* (New Haven, CT: Yale University Press, 2017). On Van Krimpen, see Sebastian Carter, 'The types of Jan van Krimpen', in *Type & Typography: Highlights from 'Matrix'* (West New York, NJ: Mark Batty, 2003). For the Unicode Consortium's documentation of the latest Unicode standard, see <http://www.unicode.org/versions/latest/>. On non-Latin type design, see Fiona Ross and Graham Shaw, *Non-Latin Scripts: From Metal to Digital Type* (London: St Bride Foundation, 2012). On Arabic

type design, see Titus Nemeth, *Arabic Type-making in the Machine Age* (Leiden: Brill, 2017). On typographic innovations and survivals, see Michael Twyman, *Printing 1770–1970* (London: British Library, 2nd edn 1998). On the change from printed to digital publishing, see Marilyn Deegan and Kathryn Sutherland, *Transferred Illusions: Digital Technology and the Forms of Print* (Farnham: Ashgate, 2009); Michael Bhaskar, *The Content Machine* (London: Anthem Press, 2013); Julian Baggini, 'Ebooks v Paper', in *Financial Times* (20 June 2014; at <https://www.ft.com/content/53d3096a-f792-11e3-90fa-00144feabdc0>). On the decline of the print newspaper and its digital future, see Marty Baron, Reuters Memorial Lecture at the University of Oxford (16 February 2018; at <https://reutersinstitute.politics.ox.ac.uk/risj-review/video-risj-memorial-lecture-when-president-wages-war-press-work> from 1:20:58).

Some online resources

Individual writers on typography: Matthew Butterick <https://practicaltypography.com>; James Mosley <http://typefoundry.blogspot.co.uk>; Paul Shaw <http://www.paulshawletterdesign.com>.

Magazines: *Eye* <http://www.eyemagazine.com/blog>; *Grafik* <https://www.grafik.net>; *Print* <http://www.printmag.com>; *Type* <https://www.typemag.org>.

Websites: I Love Typography <https://ilovetypography.com>; Letterform Archive <https://letterformarchive.org/>; Typographica <http://typographica.org>; Typotalks <https://www.typotalks.com>.

Commercial websites: Fontstand <https://fontstand.com/articles>; FontShop <https://www.fontshop.com/news>; Type Network <https://www.typenetwork.com/news>.

Index